REALISTIC PAINTING WORKSHOP

QUARRY

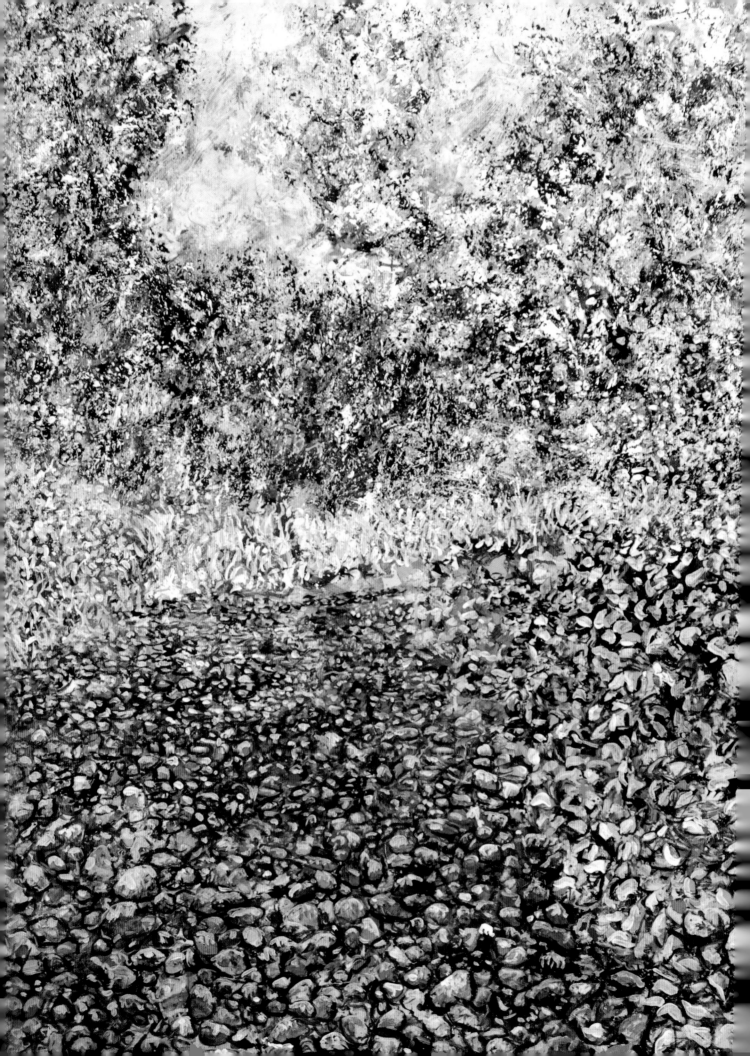

REALISTIC PAINTING WORKSHOP

CREATIVE METHODS FOR PAINTING FROM LIFE

BEVERLY MASSACHUSETTS

QUARRY BOOKS

Dan Carrel's
TRANSFORMATIONAL
PAINTING METHOD
Step-by-Step!

First published in the United States of America by
Quarry Books, a member of
Quayside Publishing Group
100 Cummings Center
Suite 406-L
Beverly, Massachusetts 01915-6101
Telephone: (978) 282-9590
Fax: (978) 283-2742
www.quarrybooks.com
Visit www.Craftside.Typepad.com for a behind-the-scenes peek
at our crafty world!

Library of Congress Cataloging-in-Publication Data

Carrel, Dan.
 Realistic painting workshop: creative methods for painting from life / Dan Carrel.
 p. cm.
 Includes index.
 ISBN-13: 978-1-59253-637-5
 ISBN-10: 1-59253-637-9
 1. Painting--Technique. 2. Realism in art. I. Title. II. Title: Creative methods for painting from life.
 ND1500.C35 2010
 751.4--dc22

 2010018100
 CIP

ISBN-13: 978-1-59253-637-5
ISBN-10: 1-59253-637-9

10 9 8 7 6 5 4 3 2 1

Design: Kathie Alexander
Layout: Sylvia McArdle
All paintings by Dan Carrel unless otherwise credited.
Musée Marmottan, Paris, France/Giraudon/The Bridgeman Art Library International,
32 & 33; Sterling & Francine Clark Art Institute, Williamstown, USA/
The Bridgeman Art Library, 37; Ringling Museum of Art, 38

Printed in China

CONTENTS

4th of July Kansas River,
oil on canvas, 18" x 48" (45.7 x 122 cm)

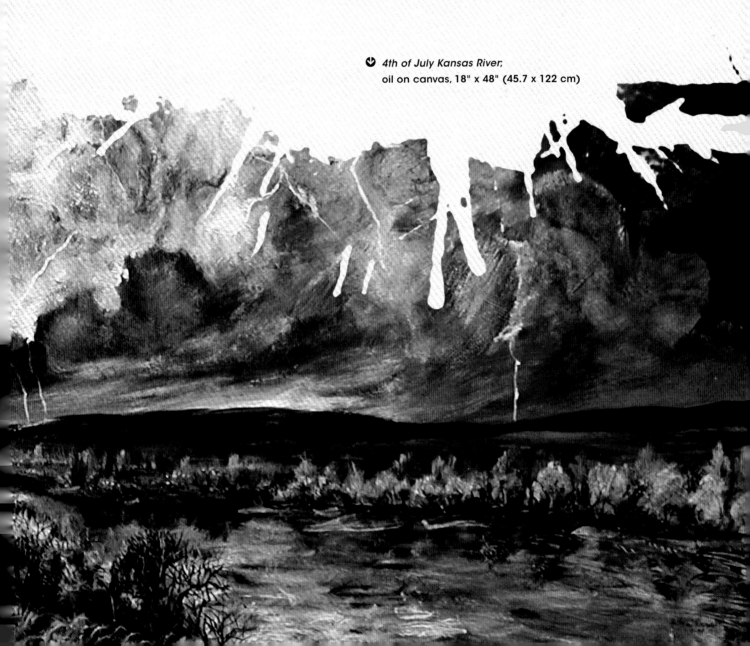

INTRODUCTION

I HAVE BEEN AN ART TEACHER and a profess-
ional artist for thirty-four years. Although I have
taught at several universities and colleges, much of my
experience and passion are in helping nontraditional
students relearn how to access the mental functions
associated with art. After working with approximately
10,000 people over the years, I have come to the
conclusion that almost everyone has the capability to
personally experience the essence of art in their lives. For
every 100 people who follow the technique I discuss in
this book, roughly ninety-eight will be able to reproduce
complex images through the traditional art mediums
in a matter of hours.

How can this be? We were taught that we could not
be visual artists unless we were born with artistic talent.
We were also taught that most people have the capacity
to learn to read the world verbally and mathematically
but not visually. In my classes, I reintroduce my students
to some of the seemingly simple visual games we all
played as children and then demonstrate how those
games are actually the complex foundations of visual art.
When they learn to play again, the visual world opens
up for them. They go back to their jobs and families
with a renewed sense of joy. Many of them find that
their problem-solving skills are enhanced because they
have become more visually aware of the patterns in
their complex world. Even better, their emotional and
physical health improves. Art is the original chemo- and
psychotherapy.

People from all walks of life, including professional
artists and designers, have taken my classes because of
the remarkable results they've seen from people who
considered themselves complete beginners. With this
book, I hope to capture the artist in everyone.

⬆ Dan and his "teacher" granddaughter

1

UNDERSTANDING YOUR BIRTHRIGHT AS AN ARTIST

Everyone has the potential to be an artist. In fact, we were wonderful artists by the time we were four years old. Then, as we got older, we were told that we had to be talented to be an artist—that is, to be able to visually sculpt, paint, or draw. But no one told us that we needed talent to learn math and writing skills—to sculpt, paint, or draw with words. We could learn math and verbal reading without a talent, but we couldn't learn art structures without it.

In school, we learned to read and write using a verbal alphabet—our ABCs. And, if we put the letters together in the right order, we create words that everyone can understand. But we do not learn a standard *visual* alphabet that enables us to communicate visually, despite the fact that 13 percent of us can learn to visually read, paint, or draw very realistically when given a blank page. Instead, we falsely describe that 13 percent as artistic and talented and give the remaining 87 percent of our population an excuse for being visually illiterate. Our society expects the visual-artist population to be verbally literate but in turn does not expect the verbal-artist population to be visually literate.

➔ *Tyco Wave*, Window Blind series; acrylic on woven canvas strips behind a canvas/wood lattice, 3" x 48" x 78" (7.5 x 122 x 198.2 cm)

↑ *Aspens*; acrylic on canvas,
44" x 36" (112 x 91.5 cm)

THE TALENT MYTH

We all can learn to paint, draw, or sculpt realistically if we have the right instructor or need. There is enough hardwired programming in our brain to do almost anything in an average way. To be able to draw a realistic, recognizable image is equal to being able to write a complete sentence.

True talent is the ability to immediately access a universal human ability—such as painting, running, singing, and working out complicated math problems—without training. It is a genetic memory that is passed down through a person's genetic makeup. To write a novel that brings new insight to the world or to paint a portrait of a woman whose perfume you swear you can smell is the product of talent. Being able to write a complete sentence or paint a recognizable portrait is learned and is not true talent. Great artists, mathematicians, writers, musicians, and singers rely on a powerful talent, but the average person can learn to paint, write, sing, play music, and do math in a competent way without requiring a special talent.

Normally, we all have arms and legs, but very few of us are Olympic athletes. A runner is not necessarily talented if he can run faster than you. He's talented if he can run faster than most people. But we all have an ability to run, because a basic knowledge of running and walking is hardwired into the brain. The same principal applies to art. Most of us have the necessary components of visual thinking or art; to be a competent artist, we might only have to learn or practice one small component that we did not have immediate access to at birth.

We need to realize that our present society's definition of visual talent is wrong. Society determines what is average and what is talent and what is important. Our society sets low standards for visual reading (art) and high standards for verbal reading (language) because verbal reading is falsely perceived as more important than visual reading. If it were perceived as equally important, most of the population would be able to paint, sculpt, and draw with the same ability the average person has to read a book.

Historically, society had the same misconceptions about reading, writing, and mathematics; 500 years ago, the average person believed that it wasn't possible to learn to read without having a talent for it. In fact, it was true, because the educational system excluded average people. However, if you went back to that time, before the era of mass-production of goods, you might be amazed by how talented the average person was at making things, compared to our present times. These skills were learned out of necessity and valued by the larger society. They were crucial to its success. But the ability to paint, sculpt, and draw is not perceived as a necessity for survival in our society. If we all had been given enough opportunity to practice art, and if society had given more emphasis to visual thinking compared to verbal thinking, we would all be decent visual artists.

Endorsing a one-dimensional thinking and learning style in our academic institutions has created some serious problems for our society—40 percent of our first-grade children are creative-thinking and right-hemisphere dominant, and very few of them finish college; creative thinkers comprise 80 percent of our prison inmates. Their self-esteem is starved from a bigoted learning-style hierarchy, tinting their creative solutions with anger and fear.

An excellent educational system employs teachers who realize that their job is to find each student's particular problem-solving talent and reveal how it is an integral part of opening all doors of knowledge; it is not to impose on these students their own or society's intellectual biases. The latter creates an excuse for the teacher and student to fail. The failure is not the lack of a specific talent combination but the belief that all individual talents are not necessary to fully solve every problem. When brainstorming to solve a complex problem, most talent categories come into play, from spatial thinking to mathematics. Visual thinking is at the top—how can you visualize a problem without being trained visually? Each specific talent is made up of smaller common intellectual components of information that are arranged like notches and points on a key. Each talent-key combination fits certain problems perfectly but also can help unlock any problem. The more keys you have at your disposal, the more doors of information you can unlock.

The truth is that everyone has immediate access to part of the talent lock. To be healthy in mind, body, and spirit, we all need the powerful emotional energy generated by our talents. Being able to solve problems in our own way motivates the creation of new intellectual keys that will eventually open the doors to all knowledge. We should all be given the opportunity to learn in all learning styles, which can give us clues for using our talents in new ways.

No individual has the perfect set of talent tools to solve a problem completely. The best solutions come from outside the traditional talent box within a group of distinctly different learning styles united by a common bond of passion for discovery. Our education and working systems need to endorse a program of teaching and working that includes both creative and critical thinking. The more creative-critical combinations an organization has, the greater its problem-solving power.

Supporting Creative Thinking at Work

In the last 100 years, jobs for creative thinkers have disappeared. Craftsmen, artisans, even farmers who have to be very creative in their gamble on the environment are almost gone in the United States. Corporate CEOs are sometimes creative and critical thinkers, especially if they created their own companies. Companies need creative people but demand environments that only cater to the critical-thinking management styles, thus making a distinctly unfavorable environment for its creative workforce.

PROBLEM SOLVING THROUGH VISUAL LITERACY

Although our society heavily favors learning verbal and mathematical languages, the birth-mother of these languages is *visual* communication; ideas are always discovered visually and then translated into these other languages. Unfortunately, we've forgotten that visual literacy is one of our most important thinking tools; one that can bring new concepts and rare ideas into the world. In fact, some of our best creative thinkers were labeled learning-disabled, because they thought with the "wrong side" of the brain. In other words, they use an unpopular thinking style to solve problems. Many of the greatest writers were not gifted grammarians, but they were excellent storytellers. And, though Einstein flunked high school algebra, he knew how to ask the right questions.

The visual structures learned through the arts enhance the mind's capacity to learn and solve problems! Combining the intellectual tools used by the visual, verbal, musical, and mathematical arts gives all of us the chance to use our individual unique talents more effectively and extend the understanding of our potential.

We are all talented, and within the structure of each of our unique personal talents are the essential components that can universally unlock all information, including visual art. This book is a blueprint for resurrecting that important knowledge you used as a child and applying it to your adult life with the joy of a child and the wisdom of an adult.

SIDEWALK DRAWING EXERCISE

Before you can learn how to paint or do anything new, you need to understand what you already know about the subject. The key to transformational painting is to realize that you are already an artist and that your ability to paint is within you; it's just waiting to be discovered. This exercise is a good way of proving to yourself that you have sophisticated and complex universal visual-thinking tools already in place and can illustrate complex concepts in a powerful, succinct way. This exercise also reveals how your talent components and personality influence visual thinking.

I have given the following sidewalk drawing exercise to hundreds of people over the last thirty-four years and have come up with some very similar, predictable data proving that we all are able to produce complex sophisticated visual symbols that transcend gender, race, age, and societies. This simple exercise is full of important information to give you the confidence to paint.

To perform this exercise, you'll need to gather together some friends, family members, or even coworkers. They don't need to be interested in learning how to paint to participate, but they might find themselves enjoying the exercise and learning something about themselves—and others in the group—in the process. You will notice that everyone becomes relaxed and happy and that the concept of time passing disappears—a common occurrence when you are thinking with the right hemisphere.

tip

You will find that you grow faster if you can work on these exercises with other people. With this book, you can learn to paint by yourself, but to grow as an artist and use your talents to full capacity, you need honest critical evaluation by people who are struggling with the same problems. We are all students and teachers when we create. We all learn from each other's mistakes and triumphs.

Step 1 Place a length of white paper approximately 2' x 12' (61 cm x 3.7 m) (a roll of newsprint or printer paper works well) on the floor to duplicate a sidewalk, and have at least five adults sit on both sides of the paper sidewalk. Pass around a large container of assorted colored crayons and have everyone take some crayons and pass the tray to the next person. As the crayons are passed, note how each individual handles theirs. Some might organize the crayons by size or color, some might stack them like Lincoln logs, others might just leave them in an un-collated pile. Some might even take crayons from their neighbors without asking!

Step 2 Have people close their eyes and visualize their earliest pleasant memory. Allow at least two minutes for this. When everyone's facial expression has softened and relaxed, have them open their eyes and pretend they are four years old for the duration of the sidewalk drawing.

Step 3 Now, illustrate the five following concepts without using recognizable realistic symbols, words, or shapes—to illustrate in the pure abstract. Be sure not to draw the concepts in order or number them at this time.

1. Fear
2. Sex
3. Hunger
4. Happiness
5. Eating an ice-cream cone in the hot sun

Step 4 When finished, have everyone stand and walk clockwise around the sidewalk, giving each drawing a black crayon number that they feel corresponds to the concept. (For example, a participant who feels that a particular drawing represents Hunger would give the drawing a black crayon number 3; one that suggests Happiness would be given a number 4.) Ask the participants not to be influenced by others but to be honest.

Step 5 When the drawings have been numbered, have everyone sit at their own drawings and number them in red crayon. The red crayon numbers reveal to the rest of the group which drawing was intended for which particular concept.

Step 6 Have the participants stand up and look at all of the drawings and numbers, noting which drawings were correctly guessed. Remember, the black numbers are the participants' guesses, and the red numbers indicate the correct concept. Then discuss which drawings fit each concept better than others. Which drawings were easier to guess correctly and why?

Step 7 Can the group see any correlations in picking certain subjects correctly over others? Were some subjects more easily illustrated than others? Do the drawings reveal universal formulas of value, line, and shape that illustrate certain emotions better than others? Do landscape shapes evoke certain negative or positive emotions—jagged mountains, for example, or soft, rolling hills? Were the participants surprised by how easy or hard it was to correctly identify the drawings?

Is there a sophisticated universal visual language hardwired into each of us? Does body language or sitting or lying down have a correlation with learning styles? Does the way someone lays out her crayons indicate a creative or critical thinker or even an introvert or extrovert? Can a person be considered contrary because his drawings were completely misread—and did he draw them so they would intentionally be misread?

The exercise is very powerful when people know each other. The exercise is also powerfully important in understanding the learning and thinking styles of people you don't know. It is also a very good tool for building teams to solve problems. Eye movement, body language, even how you lay out your crayons are influenced by your thinking and learning style.

As a teacher, I use this exercise to evaluate new students and to give the students invaluable information about themselves and how to understand others, which is the function of art.

⤴ *Birthday 1950*; oil on canvas, 24" x 32" (61 x 81.3 cm)

SEEING THE FOREST *AND* THE TREES

Our intellect decides what is visually important for the situation at hand. For example, if you are trying to catch a ball, all of your intellect is focused on the ball and its trajectory and on the body's kinetic muscle movement. Anything that is not visually important to catching the ball, such as the faces in the crowded ballpark or even the color of the pitcher's uniform, is blanked out. A child has a hard time catching a ball because the child is too visually aware of everything at once, to the point where concentrating on one specific thing, such as catching a ball, is hard.

We learn at a very young age to visually blank things out if they are perceived as unimportant to the task. In our educational systems, jobs, and daily lives, our intellect is instructed to ignore any basic innate visual patterns that are seemingly less or not important to our overall goals in life. This is a good thing when catching a ball or trying to finish a difficult project, but it can be a bad habit when trying to paint. The more you blank out something, the less visually aware you become. Sometimes we blank out visual components that are important to keep if we are to paint the whole picture.

That childlike awareness of everything in the picture is what artists try to get back to. By re-involving ourselves in art as we were as children, we can resurrect the genetic art programming that we lost along our journey from childhood to adulthood and remove the roadblocks that have kept us from our birthright.

THE BRAIN'S DUAL NATURE

Make fists with your hands and place them together so your palms touch. Your combined fists now represent your brain in size and shape. Like your fists, your brain has two halves, called hemispheres. Now place a pencil between your fingers, making a connection between your two fists. The pencil represents the nerve connection or information highway between the two hemispheres of your brain. Although a healthy brain works in a seamless fashion—both the right and the left hemispheres communicating and working with the other—each hemisphere has a unique way of interpreting the world.

Now, open up your fists and wiggle your fingers. Each finger represents a learning and thinking structure, or talent. Although the fingers on our left and right hands look the same, they are different. We have a preference, for example, in using one hand over the other or even in using a particular finger more than others. As I type, certain fingers are used to access certain letters or symbols on my computer. My finger positions are determined by the keyboard design and also, to a certain extent, by my own unique body physiology. This is similar to the way religion, education, and even society influence how we live our lives.

If our fingers represent all of our human intellectual capacity, we find, like in our hands, that many parts of the brain have redundant functions. This comes in handy if you have a stroke; if one hemisphere is compromised, it is possible to have some part of the other hemisphere take over the lost function. Using the redundant part, however, is like having a different person take over, practicing that function with a different personality and motivation.

Imagine your brain as a city divided in half by a railroad track. On one side of the tracks are the shiny, new neighborhoods, with attractive, if a little homogeneous, houses and straight, logical streets. On the other, is the older, rundown part of town. As in many cities, this part of town is usually considered to be on the wrong side of the tracks. Although the buildings on that side are old and in disrepair, they are usually beautiful and unique, built with a higher level of craftsmanship than the new side of town, with its impersonal urban sprawl. But they've been neglected.

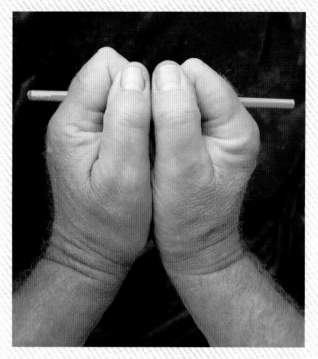

⊙ Your two fists represent the two hemispheres of your brain.

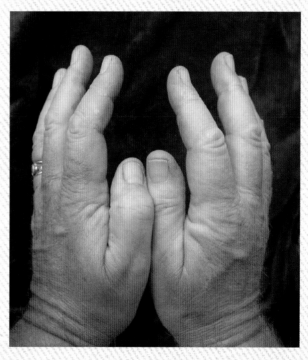

⊙ Each finger represents a learning and thinking structure in your brain.

The brain's right hemisphere is like that older part of town. The right hemisphere is programmed to see pattern in chaos, connections between unlike things, and differences in seemingly identical things. We call this creative thinking. This type of mental function creates new ideas and concepts.

The new side of the brain city, the left hemisphere, is associated with repetition—memorizing old ideas and concepts and grouping identical things together. It hates chaos. This is critical thinking. Whereas creative thinking uses chaos as a tool to create new ideas and concepts but has a hard time implementing them, critical thinking takes old ideas and implements them into the world but cannot solve problems that need new solutions. Critical thinkers need to be balanced by creative thinking so they don't always repeat their mistakes.

Our societies, communities, philosophies, religions, and almost every way we organize our lives mirror this dual nature of the brain. Physiologically, our bodies have pairs of parts: two arms, two legs, two lungs, two eyes, two kidneys, two connected hemispheres of the brain. The redundancy in our human makeup helps keep us alive and well. Sociologically, we have also divided our world into polarities: yes versus no, right versus wrong, heaven versus hell, left versus right, up versus down, black versus white, creative versus conventional. But there are gray areas between these polarities. Art describes those areas, so we can transcend the illusion of polarity.

When we artificially give one of the polarities more importance than the other, we also reduce our ability to live well. Problem solving is reduced and conflict is enhanced if any learning style or talent is placed in a hierarchy or eliminated from our education. All pre-Western-civilization societies understood this and used art as a teaching tool to help their children balance these two voices in their minds and communities. Art teaches us how to dance with those traditional polarities.

❧ *Flint Hills Reflection;*
oil on canvas
24" x 31"
(61 x 78.7 cm)

Using Both Sides of the Brain

Artists of all kinds have two different perspectives: a pinpoint, laserlike accuracy that discerns detail, which is usually associated with critical thinking, or the left hemisphere of the brain, and a floodlight beam that illuminates the entire environment of the subject, which is associated with creative thinking, or the right hemisphere of the brain. To create art, they use both sides of the brain.

All of the brain's genetic and learned programming is essential to the quality of life—the essential tools for knowledge are already built into the system. We pick and choose what is important through our own personal emotional and environmental needs. We are emotionally tied to using our personal-specific combinations of talents through chemical triggers that are euphoric and habit-forming. It feels good to solve problems with our own specific talents.

Our human intellect is like a community of personalities. As in all communities, we gravitate to personalities and intellects that make us feel good. The brain works in a similar fashion. We are genetically hardwired to use certain parts of the brain over others and are rewarded with a chemical high (satisfaction and joy, for example) if we use our talents, and suffer from chemical withdrawal (depression) if we do not. Having talent or genetic memory is like being born into a specific community in a larger cosmopolitan city. Once you understand your specific talent neighborhood, you'll have the courage to explore your birthright city through art.

It is your birthright to use both hemispheres of the brain to full potential. Art's function is to help you use your talent keys to unlock all the doors of human intellect. Learning to paint will complement the knowledge that you learned in school to help you understand how to have a balanced intellect.

⬆ *Chief Joseph's Reflection;*
oil on canvas, 24" x 30" (61 x 76.2 cm)

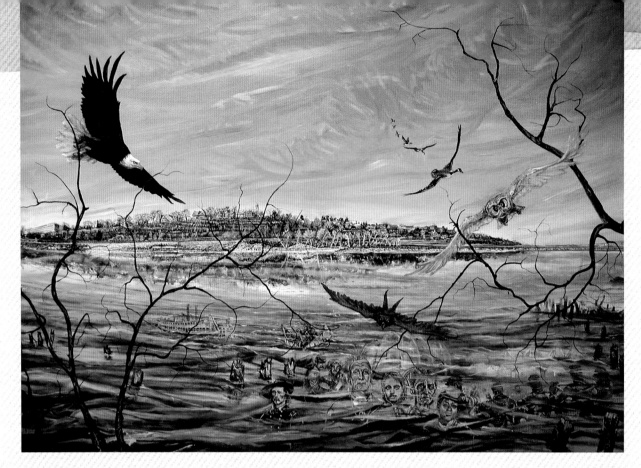

↑ *River of Time*, Ft. Leavenworth series; oil on canvas, 24" x 32" (61 x 81.3 cm)

A Stroke of Insight

The left and right hemispheres of a healthy brain are designed to work together. When the right side of the brain experiences a sensory event, the left side processes it so you can understand it. For example, if someone speaks to you, the left brain's language-processing abilities translate the sounds you hear into words and speech. You don't become aware of how effortlessly the hemispheres work together until something goes wrong. If you suffered a stroke in the left hemisphere, for example, you would not hear words when someone speaks to you, just incomprehensible sounds.

In 1996, Dr. Jill Bolte Taylor, a Harvard-educated brain scientist, suffered a stroke in the left hemisphere of her brain and found herself unable to read, write, talk, or remember details. In her book about the experience, *My Stroke of Insight: A Brain Scientist's Personal Journey*, Dr. Taylor describes how she "lost the left cognitive mind that thinks in language," leaving her with only the "right hemisphere that thinks in pictures." She describes that right-brained world as "la-la land . . . [a] euphoric nirvana of the intuitive and kinesthetic right brain, in which [she] felt a sense of complete well-being and peace."

During her eight-year recovery process, Dr. Taylor had to relearn how to walk, talk, read, write, and perform simple functions like tying her shoes, functions that we take for granted, thanks to a healthy relationship between our left and right hemispheres.

We don't need to suffer a stroke to get in touch with our right hemisphere. Through art, we can relearn to dance with both hemispheres, as we did when we were children, so our amazing creations can be realized. Great artists and scientists tap into that infinite fluid universe of the right hemisphere and bring back from their voyage of discovery wonderful gifts. Those gifts have to be shared between a healthy left and right hemisphere to gain the wisdom to use them.

CRUSHING THE PEANUT

In addition to the left and right hemispheres and their differing functions is another part of the brain, one that can keep the artist in us at bay—the amygdala. Whereas the left hemisphere governs critical thinking, and the right hemisphere controls creative thinking, the amygdala is the seat of emotion. A more primitive part of the brain, about the size of a peanut, the amygdala is where fear and rage are born. It's the fight-or-flight center and engages when you are faced with a mugger in a dark alley or a grizzly bear on a hiking trail. Its job is to pump adrenaline through the body and prepare you to fight or flee for your life. Long ago, when humans faced saber-toothed tigers and warring tribes, it was necessary for survival. Now, however, with no tigers or warring adversaries to grapple with, the only fear most of us in Western societies face is fear of the unknown.

Unfortunately, the amygdala doesn't differentiate between the fear of being mauled by a tiger and the fear of finding ourselves in unfamiliar territory.

If you grew up in an environment that encouraged both critical and creative thinking in equal measure, both intellects will be familiar and you will feel comfortable using them—your peanut-size amygdala will not engage. But if you grew up in a society that valued one over the other, you will feel uncomfortable using the weak, unfamiliar intellect. Your amygdala kicks in, and you feel fear and frustration. Your amygdala becomes critical: "Don't go there," that peanut-size critic says. "You can't do that. If you don't remove yourself from this experience, you might die!"

To learn something new, you need to know how to turn off that critic, so you can be in control again.

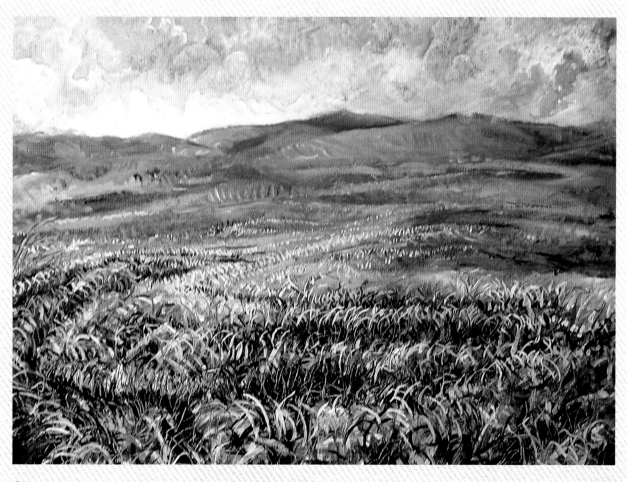

⬆ *Flint Hills*; oil on canvas, 24" x 30" (61 x 76.2 cm)

Rules for Shutting Down the Critic

1. There are no mistakes, only decisions. All decisions have a duality to them that will illuminate an alternative action in solving the painting puzzle. New solutions seem to be mistakes at first.

2. No matter how long you have painted, if you are growing as an artist, you will always feel like a beginner.

3. The painting is a process of many actions that cannot be orchestrated until the last few minutes of painting. If all decisions in creating the painting are preconceived, the painting will usually be unexciting and lack inspiration and spontaneity.

4. Everyone else's paintings will seem to be better than yours! This is a feeling that cannot be shaken. Make peace with it. We are all beginners in the long run.

5. Powerful artists finally realize that the unknown is their friend, not the enemy. To create something new in your artistic life, you have to go out on a limb, saw it off, and fall for a while, until you develop wings of inspiration. We are all creatures of habit and have a problem repeating our successes until they become devalued as tricks, instead of magical inspiration. Beware, if you do come up with something new, you may find that it was always in front of you in other artists' work. Rejoice, for you have become more aware.

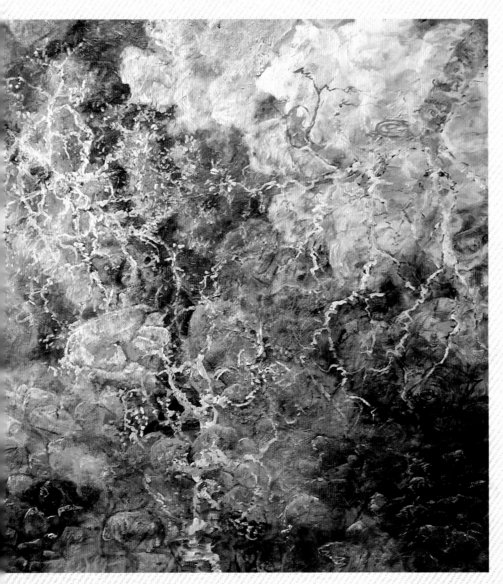

☉ *Spring Reflection*; acrylic on canvas, 48" x 52" (122 x 132 cm)

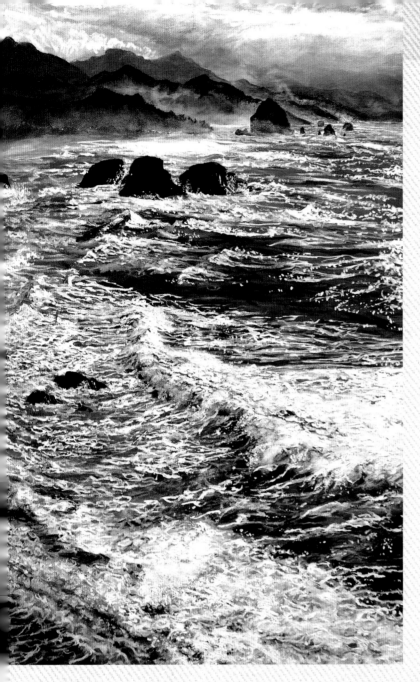

↑ *Oregon Coastline*; acrylic on canvas,
30" x 42" (76.2 x 106.5 cm)

tip

If you want to become a powerful artist in a few short years, try this philosophy:

- Painting is a tool for finding a new concept. It is not an end in itself.
- A painting is not successful if it did not lead to a new concept to explore in the next painting.
- The true function of painting is to discover something new in you. It is a tool to become more aware.
- The audience will usually understand your journey to newfound awareness if it is presented in the same innocent manner that it was discovered. Honest inspiration is universally infectious.
- Your new awareness can help others transcend to a new level in their lives. Even if others wholeheartedly disagree with your approach, your visual dance will help refine their awareness.
- Art is within everyone's reach, because everyone has a unique key combination to unlock the mysteries of their universe.

2

GOT CHAOS?
THE VISUAL ALPHABET

Thirty years ago, I discovered an ancient visual alphabet that unlocks the mind's creative visual doors, making it extremely easy to paint a complex, realistic painting—even for beginners. This visual alphabet—I call it chaos; the scientific community uses the term *fractals*—forms the underlying universal painting structure, which will influence you to see and create the basic visual patterns needed to complete a realistic painting. In effect, you will create a visual keyboard, which, in only a few hours, you will be able to play in a professional manner.

We are all programmed to see patterns in chaos. The mechanics of sight are similar to the electronic visual processing in digital cameras. Our brain breaks down the image we see into pixilated patterns, which are then processed through complex pattern-recognition centers. Our right hemisphere creates an impressionistic pixilated image of what we see, and the whole brain brings it into focus, visually and emotionally. The first step in the transformational painting process is to paint the visual keyboard, or chaos.

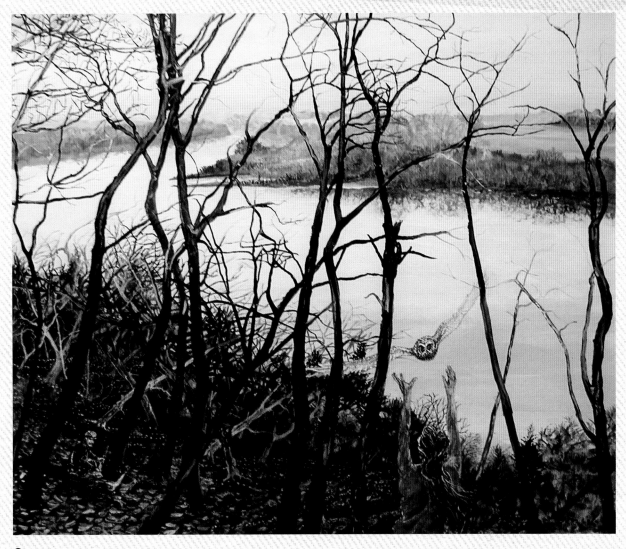

↑ *Chief Joseph's Morning Prayer*, Ft. Leavenworth series; oil on canvas, 24" x 30" (61 x 76.2 cm)

↓ *Heath's River*; acrylic on canvas, 32" x 72" (81 X 183 cm)

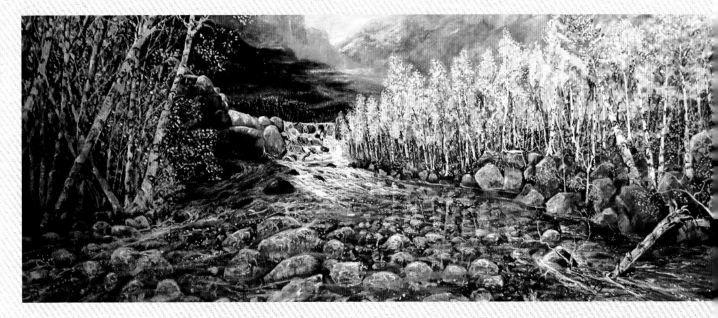

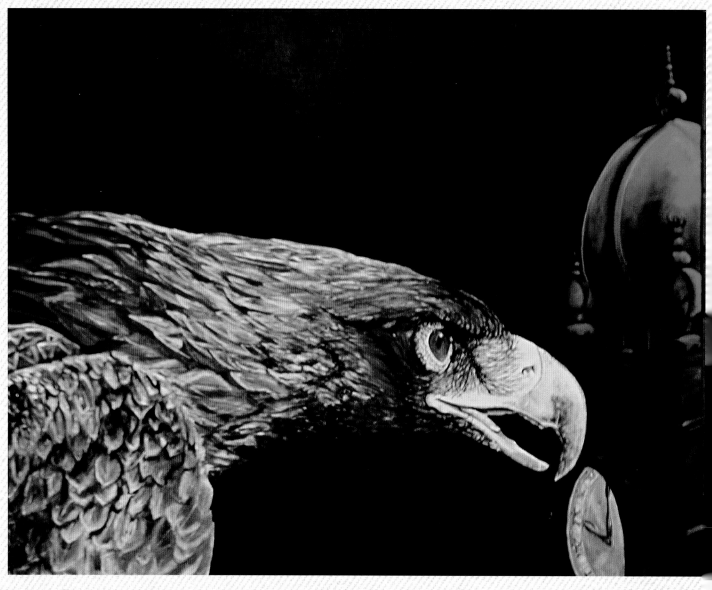

⬆ *Leavenworth Golden Night*, Ft. Leavenworth series; oil on canvas, 35" x 42" (88.9 x 106.5 cm)

The visual centers of the brain need visual information to build on or see patterns in—a blank canvas actually shuts down your visual creativity. Your job as an artist is to put something on that canvas, evaluate it, and then turn it into what you want. All creative people searching for a new idea or concept have to start somewhere beyond that blank page—and they always find their most powerful ideas by accident. Although they might start with a particular idea, they still look for that unexpected discovery that transcends their original concept. Creative people learn that outside-the-box techniques and information have the most potential for discovering powerful new concepts.

Artists discover more than they create. It can be hard on an artist's ego to admit that his or her most important work was the product of accidental discovery, that new concepts are always in plain view—in their old work and even in other artists' work—and just waiting to be discovered. When you discover new concepts, you are becoming more aware.

HOW WE USE CHAOS AS A VISUAL AWARENESS TOOL

Experienced visual artists use visual tools—a well-developed, long-term, detailed visual memory and a practiced ability to accurately judge space, distance, and shape—to develop a realistic painting or sculpture. We use these same tools to find our car in a parking lot—the application is just slightly different. To use them in creating art, beginning artists need to develop these tools through practice.

If everyone drove the same make of car, each of us would develop a more accurate description of the minute differences between our car and the others. The innate ability to discern those differences is already there; it becomes sharpened through use and the need to distinguish our car. In the same way, we see the minute differences in pets of the same breed because we are motivated to recognize our pet. We even use these visual pattern-recognition tools in our relationships with others; we recognize human emotions by discerning small changes in facial expressions.

You are a master at using the building blocks of visual reality. In fact, you use most of these blocks instinctively as you move through space. In art, we have to bring those subconscious patterns of vision into a step-by-step, conscious act to create a three-dimensional illusion on a two-dimensional space. In a way, we have to go back and illuminate those basic visual steps we learned as infants and apply them to a two-dimensional space.

If you want to paint a realistic painting, you have to realize that the necessary abstract programming to attain that goal is already in place. Motivation is the key to releasing your own individual visual talents. Motivation comes from passionately needing to record our joyful dance with life.

When I was four, I was ill with spinal meningitis. The high fevers caused scarring of my brain tissue, which affected some normal left-hemisphere functions, including speech processing, vision, and rote memorization. I was extremely lucky to have survived with so little damage, compared to many of the children in St. Louis during that 1954 outbreak. Although I did not understand the duality and redundancy of the human brain, I found, through art structures, how to improve many of my deficiencies. Singing softly to myself helped me speak and pronounce words properly. Sculpture and painting provided motor skills refinement. The most important discovery I made was to see the visible world as pattern in chaos.

For a short time, the vision-processing centers in my left hemisphere were not working properly, and I saw an extremely pixilated view of the world, similar to the impressionist paintings of Claude Monet. At times, the world around me—which, at the time, consisted of my hospital room—was so chaotic and abstract looking that, unless something moved, I could not see its shape. I could not even recognize my mother from the visual background chaos, until she moved or stood up from her chair. And as soon as she stopped moving, she again disappeared into the background, as if she had magical powers of invisibility.

The left hemisphere possesses wonderful shape-recognition centers. Yes, the left hemisphere. You probably thought it would be the right, creative-thinking side. No! The critical-thinking side is the master at shape

recognition, but it needs a strong right-hemisphere partner to create the illusion of seamless vision. If one side is out of balance or less developed, visual literacy is compromised.

By the time I was seven years old, I was drawing, painting, and sculpting very realistically. My teachers told me that I was very talented in art. I tried to explain that it was not talent in art that I possessed, just a self-taught understanding of how vision works. I realized that my teachers knew the same things I knew about art and had many of the abilities that I had, but they didn't know how to transcribe the images they saw onto a piece of paper. It's like not knowing that you need to put gas in a car to make it run. You can easily learn this, though—knowing how to make a car run is not having a magical talent; it's just having the necessary information.

My talent was the ability to find shapes in a complex scribble. The more complex the scribble, the more complex shapes would appear. My teachers saw complex patterns in numbers and letters that I did not see. Unfortunately, they would not let me use a lack-of-talent excuse for my math and spelling deficiencies.

You have to have something to look at (chaos) before you can see shapes in it. It is too difficult to pull the correct shapes out of a blank sheet of paper. My first realistic drawings at four came from copying the entire *Little Blue Book of Birds.* At first, I just scribbled and then looked for the bird shape in the scribble. Once I found the correct shape in my scribbles, it was easy to transfer it onto a blank sheet of paper and remember it. The scribbles taught me how to make the eyes, the feathers, and even the trees. We all learned to see through chaos. We've just forgotten the first step.

FRACTALS: UNDERSTANDING THE VISUAL ALPHABET

If you observe nature closely—through a microscope, for example, or by looking at macroscopic photos—you will often find that every shape inside an object's perimeter shape mimics the outside shape of the object. For example, a crumpled leaf is made up of smaller crumpled leaf shapes! We call these complex visual-building-block shapes fractals. They look like interlocking puzzle shapes, similar to army camouflage. Everything with a texture seems to be made up of these microscopic to monumental curvilinear interlocking shapes.

In the following exercises, you'll learn how to use simple objects made from paper and organic materials as paint stamps to print fractals. These stamped fractal shapes form the basic textures of the complex realistic world. Knowing how the stamped fractals look and work will make it easier to learn how to make them with a brush. You will also discover that using a stamping tool can be faster and can create more realistic textures than using a brush. Most important, you will be able to see images in those chaotic fractals.

Fractal Exercises

Finding Basic Fractals

This exercise reveals an important visual paradox: Although the visual world can be created with unique complex fractal shapes, those unique shapes can be categorized into only five basic shape styles. In other words, the visual fractal alphabet has only five letters to memorize! You'll find that it is almost impossible to make more than five fractal shape styles if you follow the instructions.

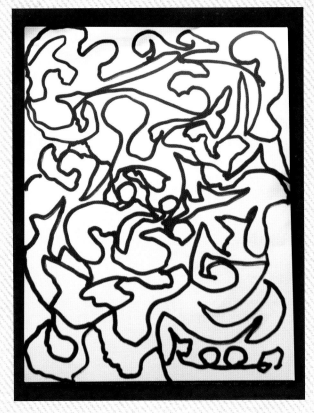

↑ Draw interlocking shapes on a sheet of paper.

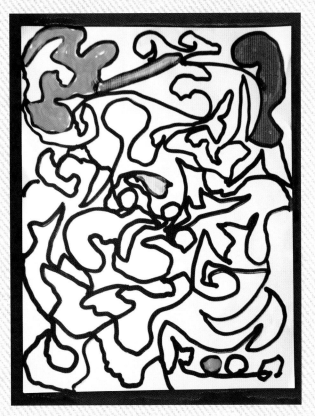

↑ Finding the basic fractals

1. Use a black marker to draw interlocking shapes on a white sheet of paper. Try to create as many different interlocking shapes as you can. Try not to repeat a shape or use straight lines. Once you start, do not lift your marker off the paper until the paper is covered.

2. Study the fractals you made and try to determine five basic kinds. Color each of the five types of fractals with a different color. Any color will do (in our example, we used blue, pink, yellow, red, and green). The color helps you distinguish them better so you can memorize their shapes. Keep this exercise on hand as a reference till you memorize these styles and can locate them in place as thebuilding blocks of your visual world. The visual alphabet uses only five basic fractals in uncountable combinations of size and interlocking shapes.

The five types of fractals (see photo), top right are:
oval—nonsymmetrical (blue)
blade—long, skinny, curvilinear triangle (pink)
shield—leaf shape (yellow)
amoeba—curvilinear, cell-like shape (red)
composite—a shape that has all of the above
attributes (green)

Like the verbal shapes in written languages, these visual shapes combine to make meaningful forms in a 360-degree radius—they are not strung in lines, like verbal words, sentences, and paragraphs. The fractals' puzzlelike shapes can be connected in all directions on a two-dimensional plane, much like a crossword puzzle but with infinite angles of connections. This connectivity creates a greater probability of creating visual words than you would find when making verbal words from random letters strung in only one line of connection.

Most beginning artists look for rectangles, straight lines, triangles, and circles when they attempt to paint and draw, instead of searching for curvilinear fractals. As verbal readers, we are so well trained to do this that we have trouble seeing anything else. The key to seeing fractals is to start by first trying to break down every visual subject into triangles. When you can do this, you will notice that the thick and thin triangles are very curvilinear. Now, try to see all the ovals in the subject matter.

Your job as an artist is to break down your subject into a series of two basic shapes: oval and triangle. Once you start to see and paint those shapes, you will see smaller and smaller combinations that eventually melt into fractal shapes. The next step, through practice, is to recognize the fractals without having to break the subject into its basic oval and curvilinear triangle shapes.

The color and value of the interlocking fractal shapes that make up textures behave like notes in music. The specific fractals as a group have underlying individual size-and-shape relationships that fit the texture of the object. This acts like the rhythm in a music score. Musicians know that the underlying rhythm in a musical composition is an essential framework for the rest of the composition. Musicians also know that there are only a few basic rhythms.

Likewise, visual artists realize consciously or subconsciously that there are only a few basic visual shapes, textures, or rhythms that make up our infinitely complex world. Part of the mind automatically sees ovals and triangles and is hardwired to combine them into the five interlocking universal fractal shapes. These fractal shapes can visually make anything. Even the visual surface of your brain is made up of fractal shapes.

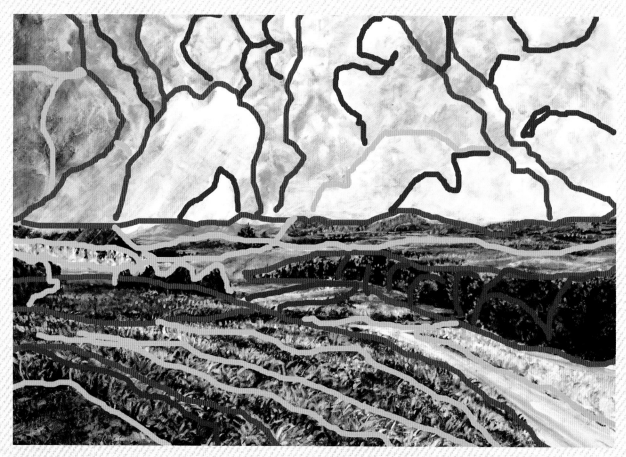

⬆ Drawing the fractals on a photograph of a landscape

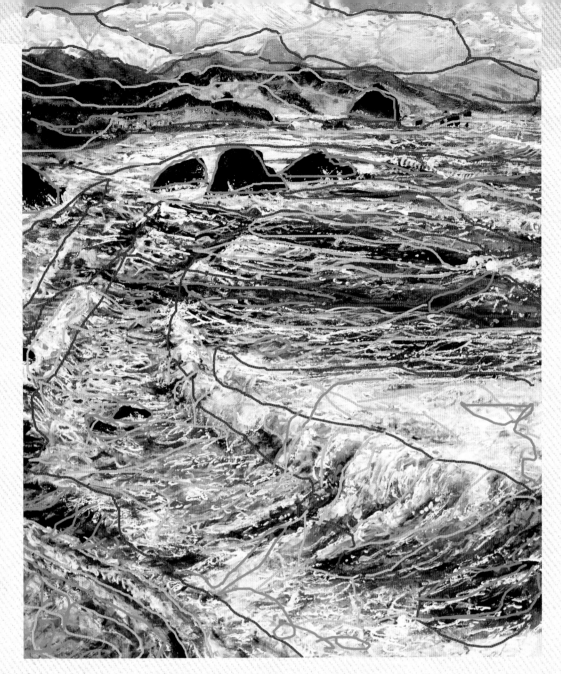

↑ Drawing the large, medium, and small fractals

Recognizing Fractals

1. One of the best ways to understand fractals is to print out a photo of a complex landscape and draw on it all the large and small triangles you see with a black marker. Then draw all the ovals you see. You will notice that the triangles are curvilinear and the ovals are not perfect in shape. Fractals will automatically appear once you draw the nonsymmetrical ovals on top of the curvilinear triangles. These shapes will always overlap, and that combination creates smaller fractal shapes. The spaces between nonsymmetrical ovals adjacent to curvilinear triangles also become fractal shapes.

2. Make your eyes unfocused so your vision is blurred, and draw any basic fractal shapes you see with a red marker. You will find that after you draw a few fractal shapes the whole print will turn into nothing but fractal shapes. You will also recognize that the fractals sometimes string themselves together in a spiral formation, like the interior of a shell or the way branches are arranged on a tree or water moves.

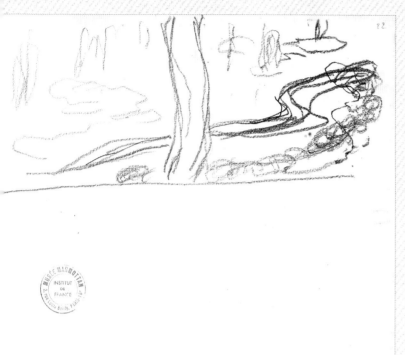

Claude Monet quickly painted the fractals in the first few minutes of his paintings (purple pencil on paper, left). *Weeping Willow and the Water Lily* (1916–1919), oil on canvas, (right).

- With your eyes closed, make five simple abstract scribble drawings in a small, blank-paper notebook. Now try to find things in your environment that look like each of the drawings. Don't be afraid to look at very small things as well as at the mountain out your window.
- A fun game to play with adults or children is to have one member of the group make a few quick marks on printer paper with a black marker. Pass the paper to another group member and have him or her turn those few simple marks into a realistic image in one minute. Always give the artist at that moment the option to pass. When the artist is finished, have him or her hand the pen back or to someone else to complete the drawing. Be sure to make the first marks combinations of curvilinear and straight, nonorganic-looking lines. Try not to repeat a line or shape. If you do this with a large crowd of people, you will be amazed at the complexity of the images created. An 18" x 24" (45.7 x 61 cm) newsprint drawing pad on an easel works better for a large group of people.
- Find an 8" x 10" (20.3 x 25.4 cm) photograph of a dog or cat or any animal with textured fur and use a craft knife to carefully cut the animal from the photograph, keeping the background intact. Place the background over various textures, such as a crumpled towel, rug, grass, a wood-grain floor, tree bark—anything with a natural texture. You'll find that some of these underlays have an astounding correlation to the look of the animal in the photo. Try to synthesize the animal's fur by creating several quick textural abstract paintings on paper and using them as underlays. Pick the best one and then elaborate by adding the features of the animal. While you are putting in the details, you might find that 75 percent of the image is already accidentally done.

Drawing the Fractals

Make another print of the same complex landscape you used in the first exercise. Blur your vision and draw the large, medium, and small fractals without performing the other steps. Use different colors of ink to denote the three sizes. This exercise trains your conscious mind to see what your subconscious sees automatically. Visual talent is the ability to see on a conscious level what everyone sees subconsciously. We will learn to paint the fractals in the next chapter.

Exercises to Reawaken Your Ability to See Pattern in Chaos

- Cut two large photographs of nature into approximately 1" (2.5 cm) squares. Put the cut squares into a bowl and mix them up, then reassemble them in an arbitrary manner. You will find many incidences where completely different materials resemble each other.
- Over a few days, choose one or two squares and try to find similar textures in your surroundings. This simple exercise will train you to see pattern in chaos and actually reawaken your conscious visual intellect to what you do subconsciously every second!

For examples of basic fractal rhythms that create specific textures in my work, see page 132–133 in the "Gallery."

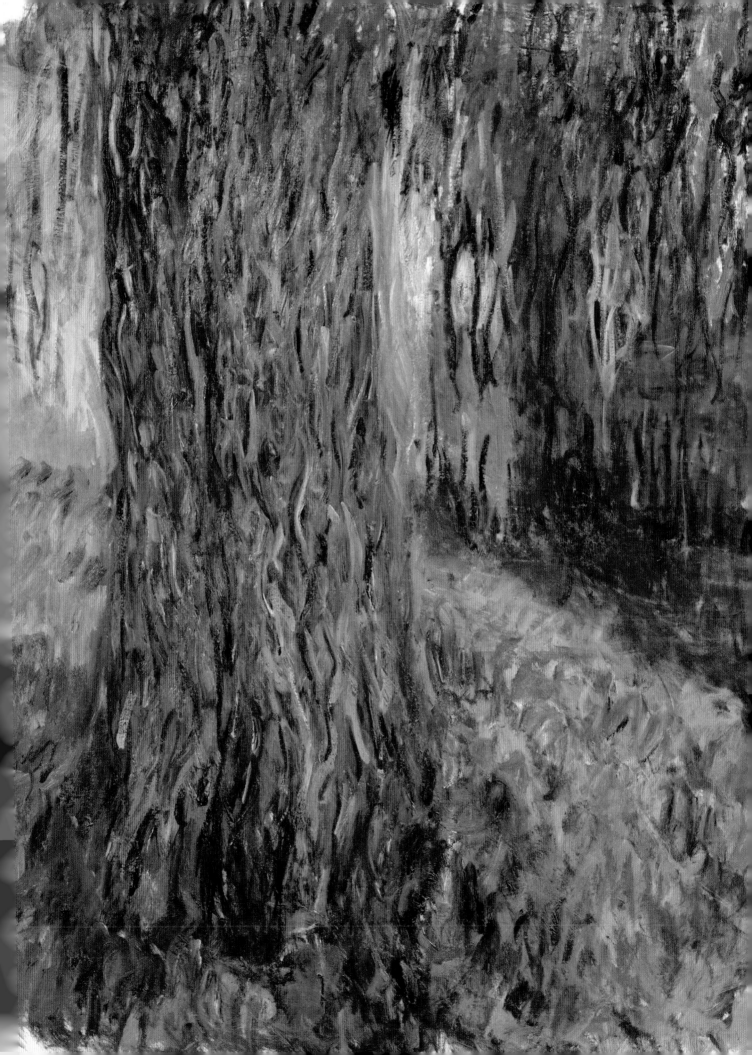

3

MATERIALS, TOOLS, AND TECHNIQUES

I have known many artists and can even attempt to put them into two categories:

Structured Artists—artists who are emotionally tied to their subject matter, techniques, tools, materials, and place of work (the studio). They are easy to document and emulate.

Spontaneous Artists—artists who are not emotionally tied to any particular subject matter, techniques, tools, materials, or place of work. Experimentation is their most valuable technique, and questions are their tools to investigate the environment. The present-moment environment is their place of work. The spontaneous artist is difficult for the beginner to document and to emulate, and self-help art books usually do not take on the daunting challenge of documenting their creative processes.

Most powerful artists jump between these two very essential philosophical learning and thinking styles. Creativity demands spontaneity and production demands structure! If you are attempting to do something new, always try to understand what has been done before (structure) and then follow the path not taken (spontaneity). Try to break the rules. This is a sure path to self-awareness of your own unique artistic power.

This book is not a traditional technique-based book. It is not about how to clone someone else's techniques and try to make them your own. It will give you a structured introduction to the basic information you need to know to start painting, and then help you find your own path back to the childhood spontaneity and wonder within you to unlock your creativity.

By the end of this book, you will have gained useful insights and working blueprints for approaching the spontaneous-artist philosophy. The first and most important insight is that every adult was once a spontaneous artist by the age of four. Getting back to that stage of wonder takes some work as an adult, but everyone's memory of that time can be reawakened through the exercises in this book.

tip

Art (visual thinking) is more than just creating recognizable images; it is a tool to understand who you are and why you are here (creative thinking). Without this goal, you are just wasting your time and will never create something worth more than your supplies. Remember that you have always been an artist because you are a human being and it is your birthright to express your humanity.

USING COLOR

Color scares most new artists. Remember that first watercolor set you received in grade school? How fun it was to be messy and how breathtaking those brilliant wet colors looked? Then tragedy struck! The beautiful flowers, sun, sky, trees, and even your house turned brown and ugly. Deep down, you have never forgotten this failure. The colors in your watercolor painting turned brown because you mixed the wrong colors together, not because you mixed too many colors together.

The easiest color to mix is brown! It is so easy to make that we have to take steps to keep from making it so our paintings don't become muddy and dull. Mixing opposite colors on the color wheel—these are called complementary colors—will always make brown.

Complementary colors can be your downfall or your salvation as an artist. Mix complementary colors together and you create mud. But place two complementary colors side by side and they try to take on each other's

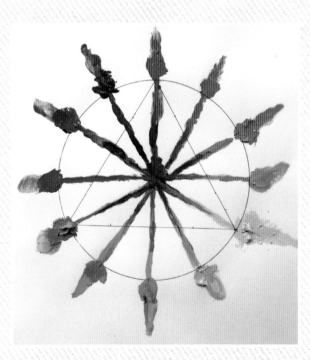

⬆ Complementary color mixing; opposites on the color wheel will mix brown

35

tip

Brown is always just around the corner. Always be aware of creating brown, so your paintings do not become muddy. Transparent paint is more likely to get muddy than opaque paint. It is also more brilliant than opaque paint because the transparent layers reflect light from the white of the gessoed canvas.

qualities and vibrate where they touch. This visual vibration makes both colors look more brilliant. Artists call this "color relativity," because all colors are influenced by the color set next to them. A red paint color set against a blue background, for example, will look different when set against a green background.

In the illustration below, the longer red stripes are all the same color, but when they are placed next to other colors, each stripe appears to be a slightly different color of red. The impressionist painters tried to capture sunlight by juxtaposing equal-value flecks (small paint strokes) of complementary colors to push the brilliance of the colors. The Ashcan School of painting tried to do the opposite by mixing complementary colors together to create the somber look of the coal-fired industrial revolution.

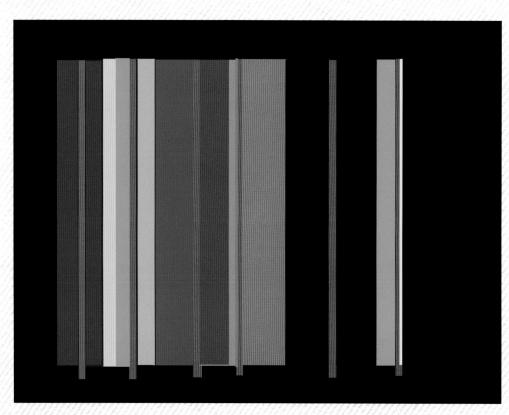

⬆ **Color relativity: These red stripes are all the same color—each looks different, however, when placed next to different colors.**

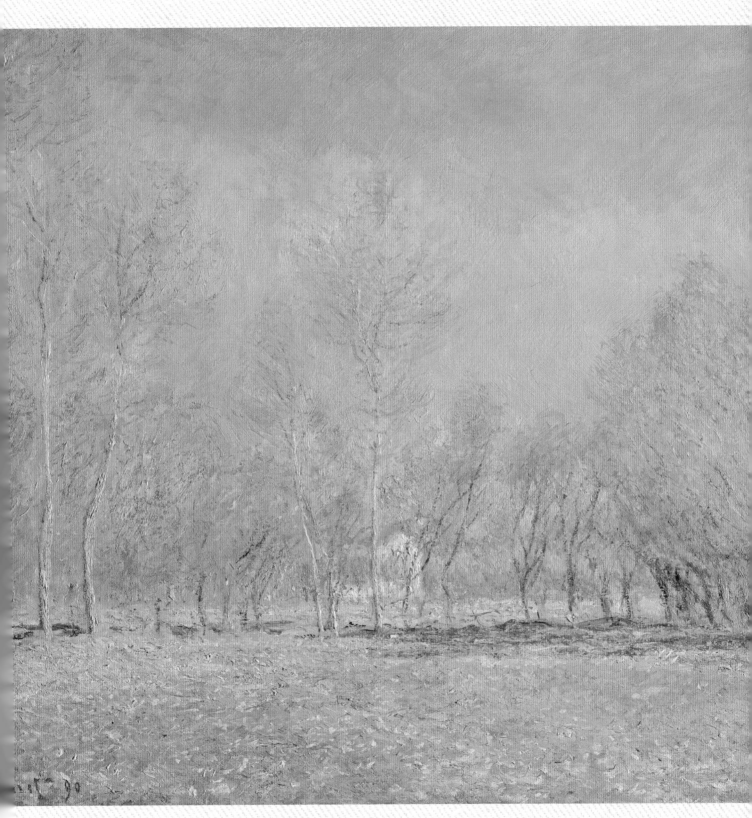

⬆ *Spring in Giverny*, Claude Monet, (1840-1926); oil on canvas, 26" x 32" (66 x 81.3 cm). Monet uses juxtaposing complementary colors of yellow, purple, and magenta to add more brilliance to this impressionist composition.

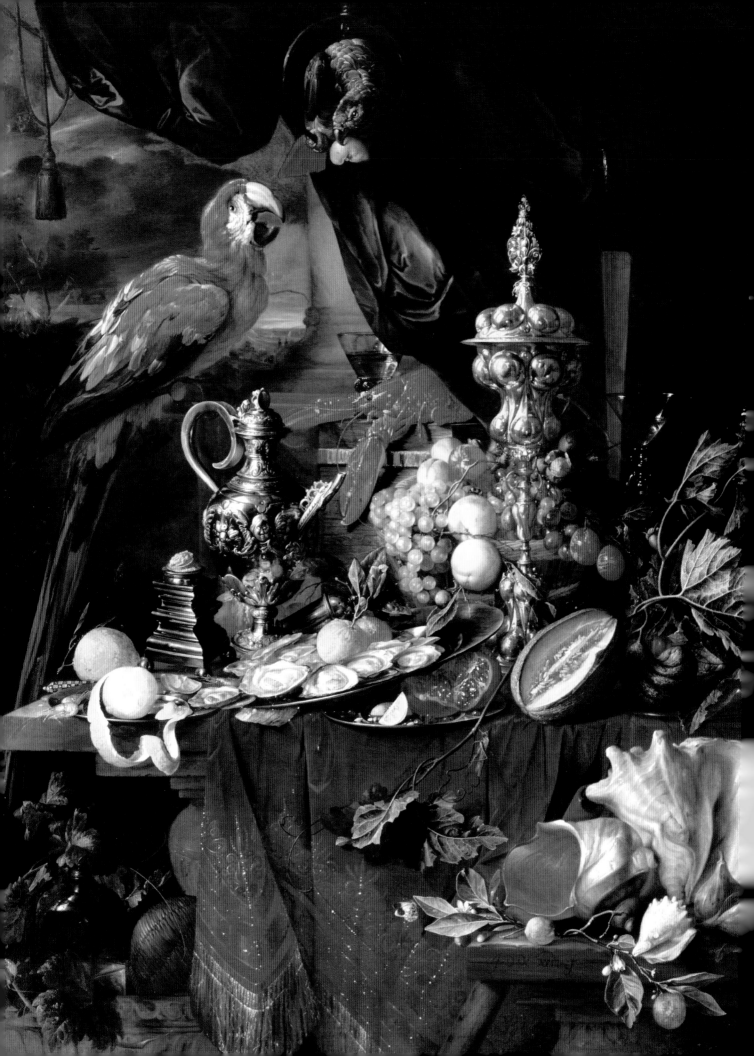

The Three Properties of Color

Value and Brilliance

The paint properties of value and brilliance cause a lot of confusion among beginning artists because their definitions are so similar. The definitions become particularly confusing when mixing colors:

- When you change a color's brilliance, you also change its value.
- Adding a complementary color to another color can change its value and brilliance.
- Each color is not the same value at its height of brilliance.
- Some colors will become more brilliant if you add white; some will become less.

Traditionally, *value* is described as the relative lightness or darkness of a color and *brilliance* as the intensity or saturation of a color. Over the years, many art schools have tried to overcome the confusion between value and brilliance for their students by using the following definitions:

Value refers to the total amount of light reflected from the painted surface.

Brilliance is how much of a specific color of light is being reflected from the painted surface.

Every color has a specific frequency of light, which is reflected back to your eye; all the other frequencies of light (or colors) are absorbed into the painted surface. White is all colors, or frequencies of light, being *reflected* to your eye, and black is all colors or frequencies of light being *absorbed* by the paint.

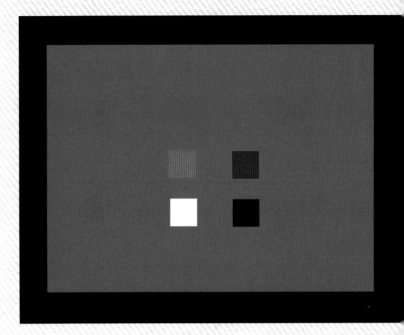

↑ The brilliant red and white squares are the same size as the dull red and black squares. Because of their higher value and brilliance, they appear larger and closer.

tip

Because of their visual properties, all colors retain a place in the picture plane's foreground, middle ground, or background. Slightly changing a color moves it to a different location in the picture plane—either toward you or away from you. This is how artists create the illusion of space and depth. Because of a color's influencing background, you might need to adjust a color to keep it in its proper place.

↳ *Still Life with Parrots*, Jan de Heem, 1640s; oil, 59" x 45" (150 x 114.5 cm). Baroque painter Jan de Heem's paintings were based on how to capture various difficult-to-paint textures. His still lifes were an astounding array of examples of almost every possible texture. Each object in *Still Life with Parrots* seems to have an inner glow that cannot be captured with opaque paint. Only transparent paint glazes can let the light into the surface of the painting.

⟲ Optically mixed color: the lower circle is made up of dots of blue and yellow. If you look at the lower circle from a distance, it will optically mix and appear yellow-green. Optically mixed paint colors are more brilliant than colors that have been physically mixed together. The same two paint colors physically mixed together, as in the upper circle, look duller.

White is an excellent light reflector. Artists use the white of the page when using transparent paint, such as watercolor, to create a *higher value* and more brilliant color because the white page reflects a lot of light through the transparent paint. High value describes the total amount of light reflected back toward your eye. Low value is the lack of reflected light.

Brilliant color shapes look larger and closer than duller colors of the same shape and size. High-value colors have the same visual spatial effects as brilliant colors. In the illustration on page 39, the brilliant red and white squares are the same size as the dull red and black squares, but the squares that are higher in value and brilliance appear larger and closer.

The function of value and brilliance is to create a three-dimensional illusion on a two-dimensional surface. The range of values and brilliances creates this illusion. A photographically realistic painting will include at least five separate values and brilliances for each color in the composition. A cartoon, by comparison, has only three separations. New artists usually do not have a wide range of value or brilliance in their first works. When in doubt, add a new value and color brilliance if you want something to look more realistic.

Hue

Hue describes the physical color or specific wavelength of light reflected back to your eyes. A paint's hue (color) is created by its specific pigment, a chemical or mineral compound that reflects a certain wavelength of visible light (color of light) and absorbs the rest. When artists talk about hue they are describing a specific color, not the color's value or brilliance index. As a rule, I don't use this term much in my teaching vocabulary, because it's a little redundant—I just use the term "color" in most applications. It is more important to know that all hues (colors) of *paint* mixed together create a brown-gray mess. All hues (colors) of *light* mixed together create white light and are reflected by white paint's pigment.

The Effect of Light on Color

One of the most frustrating things about using color as an artist is that color changes as the surrounding environment changes. All ambient light has a color, which changes the look of the colors in your painting. Paint colors look more yellow (warm) in natural sunlight and more blue-green/violet (cool) under fluorescent light. Incandescent lightbulbs cast a yellow/orange light, similar to that of the sun. Artists use north light in their studios because, unlike east, west, and south light, which changes from cool to warm throughout the day, north light remains constant all day. North light is a little more blue than direct sunlight, so many artists adjust the colors they use to a warmer look.

Complementary light colors also affect paint color. Fluorescent light makes oranges and yellows look dull but violet and blue colors look more brilliant. Incandescent light does the opposite. Many artists paint with neutral gray sunglasses outdoors so they will overcompensate and mix their colors more brilliantly and with higher values.

It's important to have a basic understanding of how to manage color so you can create your paintings in the most light-friendly environment for success. New artists trying to paint an outdoor sunlit scene while in a fluorescent-lit room can become extremely frustrated trying to mix the right colors. Once that painting is taken outside of its light environment, it will change—and usually not for the better.

You can do many things to solve this problem. The easiest solution is to paint the painting in the light environment it is to be shown in. When working in cool light, you can mix your colors warmer; in warm light, mix them cooler. You can also adjust your subject matter to suit the type of lighting situation in which the work will be hung. Hanging a beautiful fall scene in a fluorescent-lit room, for example, will render it dull and lifeless. A blue-green or violet mountain scene works better in this environment. Most artists try to create paintings that show well in mid-morning or midday light. Good galleries use artificial light that matches this type of light.

Incandescent light is the closest to sunlight, and some inexpensive, halogen shop lights produce the 32-Kelvin light that substitutes for sunlight during midday. If you have fluorescent light in your studio, you can buy 32-Kelvin-rated bulbs for the light fixtures. You can also try the new energy-saving halogen light bulbs intended for normal incandescent light fixtures, which are also close to 32-Kelvin light.

Understanding how ambient light affects your artwork can make a real difference in whether you are able to sell it. This information also works well for choosing colors for painting or decorating your house and even for putting on makeup!

BASIC STUDIO MATERIALS

My choice of materials, techniques, and subjects has evolved from a lifetime of trial and error. Over the years, I have found that the most essential tool in my artist tool bag is to experiment and then ask the simple questions of what happened and why. All artists are looking for that accident that will lead them to a new level of understanding in the chaos of our lives.

To make our creative vision reality, however, we still need some basic tools and materials, all of which have specific uses and ranges of visual applications. In this section, we will learn these specific traits.

PAINT

Properties of Paint

Pigment

Paint gets its color, or pigment, from either synthetic chemical dyes or finely ground minerals from the earth. The grade of the paint is determined by the pigment's colorfastness—the more colorfast it is, the better the grade of paint. The grade or cost of the paint is also influenced by the rarity of the mineral pigment. For example, cadmium red uses an expensive burnt metal (cadmium) for the pigment. If the word *hue* is attached to the name of the color—cadmium red hue, for instance—then the pigment is an inexpensive, red chemical dye that simulates the cadmium color. The substitute pigment is not as brilliant or as colorfast but is also not as toxic as true cadmium pigments. Nontoxic chemical pigment substitutes have become much more colorfast over the years. Some will last for more than one hundred years before they start to fade. Keeping your paintings out of unfiltered sunlight helps the colors last longer.

You can find the percentage of pigment in some paints listed on the container label; the higher the percentage of pigment in the paint, the more opaque the paint will be. This is useful information, even outside of the art realm. If you're looking for one-coat wall paints to cover your studio walls, for example, check the labels for pigment percentage. Some off brands of wall paint have a higher pigment count than the more expensive ones! You might even find some acrylic enamel house paints that are equal or even superior to the art paints you have been buying. A little product investigation can really help if you paint on a large scale or have a tight budget.

Binder

Binder is the gluelike liquid in a paint formula that helps the pigment particles adhere to the painted surface during drying. Acrylic paint uses a clear copolymer plastic varnish, similar to acrylic medium, as a binder. The binder in oil paint is linseed oil.

Binder also adds flexibility, waterproofing, and transparency to the paint. The higher the binder count in the paint, the more durable it is. Exterior paint, for

⬆ Pigment, binder (acrylic medium), and vehicle (water)

tip

Most artist paints include labels on the containers that describe their toxicity. If you use a toxic paint bearing a warning label, please comply with those warnings. Wash your hands after use, and don't eat or drink with paint on your hands. If you mix dry raw pigments into your paints, use a respirator mask. Some historians believe that Van Gogh's paints poisoned him and contributed to some of his erratic mental problems. Most hobby acrylic paints have low toxic properties so that they can be used in the school systems.

example, has a higher percentage of binder in it. Many binders are infused with antifungal, antioxidant, and even ultraviolet light–blocking properties.

Acrylic medium used in painting is the same binder used in acrylic paint and is readily available in any store selling acrylic art paint. Acrylic medium is also available in gel form for use as a non-opaque thickening agent.

Vehicle

The vehicle makes the paint liquid and evaporates during the drying period. The vehicle in acrylic paint is water. The vehicle in oil paint is usually turpentine or a petroleum spirit such as paint thinner. Normally, you clean your brushes with the same vehicle liquid that is in the paint: water for acrylics, mineral spirits for oil paints. The higher the percentage of vehicle in the paint, the lower the opaque coverage.

Buying Paint

There are many wonderful brands of acrylic art paint. My advice for beginners is to buy the best paint you can afford. If the paint is too expensive you will be afraid to experiment, and experimentation is the key to learning. Buy the kind of paint with which you can afford to gamble. Remember that most medium-priced paints will be colorfast for as long as a century. Save the expensive paint for those projects you want to live well beyond your lifetime.

tip

You can mix your own paint by adding pigment to acrylic medium. Many art supply stores sell dry pigments and also offer liquid pigments. Each pigment has a different color saturation, however, so you will need to experiment with amounts to vary the thickness and transparency of the paint. Pigment is very concentrated and goes a long way. Depending on the color, it can be quite lightfast and high quality. Black, browns, ultramarine blues, red oxides, yellow oxides, and some of the copper oxides are very good and make quite a lot of paint.

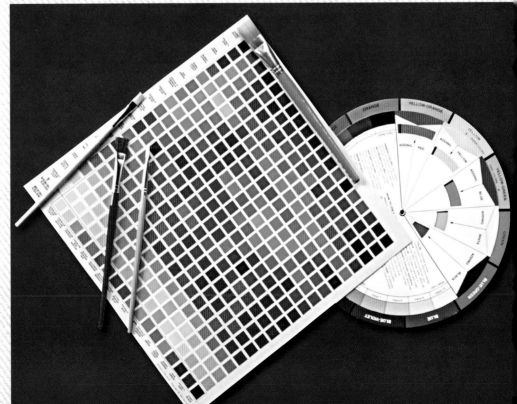

➲ **Color-mixing wheels and charts**

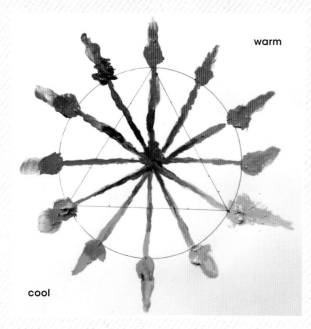

⬆ Color wheel divided into cool and warm colors

warm

cool

Mixing Paint Color

Mixing paint can be very confusing. For example, not all black and white paints are neutral in color. In fact, they can range from red/yellow to blue/violet. Some blacks, when diluted, look green or red. Mixing a warm, yellow-white paint with a light violet color will dull that color because of its complementary nature.

Pigment colors also affect paint mixing. Pigment colors differ in saturation; each has a specific saturation that is not necessarily equal to any other pigment colors. Because each brand of paint and color of pigment varies in concentration and saturation, colors cannot be mixed using any type of reliable formula. For example, one part red mixed with one part yellow will not make a medium orange. To make a medium orange, you will probably need five parts yellow to one part red, depending on the brand and type of pigment used in the paints. Experimentation and adding small increments of paint at a time to the color batch works better than trying to determine in advance a mixing formula. Mixing paints is very much like adding seasoning when you cook. And as all good cooks know, each seasoning has different flavor intensity. All peppers are not the same.

Invest in a good color-mixing tool—there are many on the market. They act like training wheels on a bicycle and can help get you started, but experimentation and asking yourself basic questions about your color mix will give you the ability to quickly mix any color. (See "Tips for Matching Paint Colors," opposite.)

Later in this chapter, we will create a multicolored background called chaos for our painting. You will learn a lot about color theory by painting over the chaos with transparent paint (glazes). The accidents that can happen in the glaze layers will teach you more about color theory than any other exercise I know. Eventually, color mixing becomes second nature, and you will find that you actually enjoy the challenge as long as you realize that any mistake can be easily fixed and that, sometimes, mistakes lead you to new, powerful techniques.

Over many years of trying different brands of paint and even making my own, I always fall back on the brand I used in college: Utrecht acrylic and oil paints. For the technique we will be using, purchase inexpensive acrylic craft paint, available in 2-ounce (60 ml) and 8-ounce (236 ml) plastic bottles available at craft stores. This type of paint is very liquid and works well. An inexpensive acrylic medium called Mod Podge, normally used for découpage, works extremely well as a painting medium and varnish.

Once you learn to paint, you can advance to more professional paint products. Don't be too picky at first. What's most important is that you paint freely instead of wishing you could.

Tips for Matching Paint Colors

Hold the color mix on your brush against the color you are trying to match and ask the following questions:

- Is it too dark or light? (Value question.) Add or delete white or black, or make it more transparent or opaque. Also squint your eyes so they are unfocused, which can help you see the value differences.
- Is it too dull or brilliant? (Color saturation question.) Add or delete a complementary color.

- Is it too warm or cool? (Hue question.) Add or delete a specific color: add yellow, red, or orange to warm up the color or add green, blue, or purple to cool the color down.
- How is the color relativity working? Colors take on the characteristics of the surrounding colors. You can make a blue look violet if it is surrounded by a red color.
- How is the contrast working? Light colors look lighter on a dark background, and dark colors look darker on a light background.

⬆ Hold your paint-loaded brush against the color you want to match and compare them.

Color Palette

I recommend a basic color palette for the first-time painter. When looking for craft paints, you'll find them listed by color: red, red-purple, orange, yellow, yellow-green, blue-green, olive green, sky blue, and dark blue, for example. Fine-art paints are named for the chemical or mineral name of the pigment used in the paint—titanium white, cadmium yellow, cobalt green, nickel azo yellow, quinacridone red, for example—which can be confusing for beginners. Color charts, which are always available in art supply stores, can help you choose the ones to buy. Buy larger amounts of black and white paints.

Basic* and Extended Professional Color Palette: ultramarine blue*, cobalt blue, phthalo blue*, phthalo green*, permanent green*, brilliant green, chromium oxide green*, quinacridone violet, quinacridone red*, alizarin crimson*, cadmium red light, cadmium red medium*, cadmium orange*, cadmium yellow light*, cadmium yellow medium, yellow ocher*, dioxazine purple*, Payne's gray, Venetian red, burnt umber, titanium white*, ivory black*, mars black

Mediums: acrylic gel medium, acrylic gloss medium*, acrylic matte medium

Hobby Paint Introductory Color Palette: dark blue, sky blue, turquoise blue, dark forest green, yellow green, olive green, burgundy red, fire engine red, red rose, sunny yellow, orange, grape purple, gloss black, gloss pure white

Mediums: Gloss Mod Podge (acrylic medium)

↻ Palette mixing trays

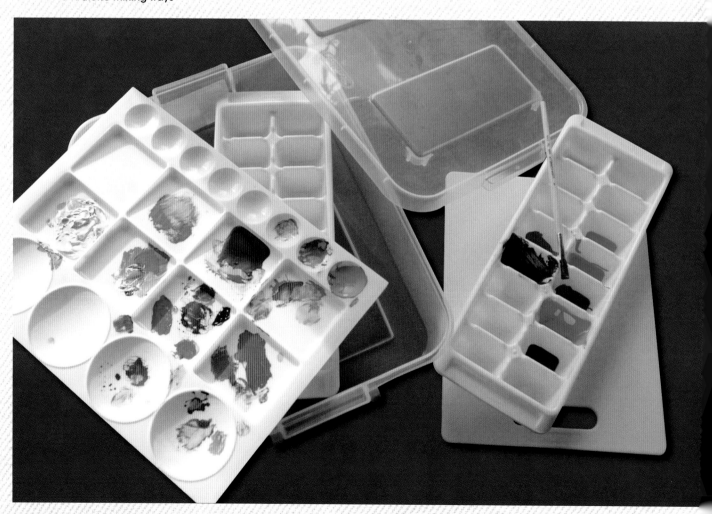

Palette Mixing Tray

I use almost anything at hand for a mixing tray, but I prefer an 11" x 14" (27.9 x 35.6 cm) plastic cake container with a sealable lid. I place several white plastic ice cube trays in the pan and use the ice cube trays to hold my paints. I use the inside bottom of the tray as a mixing palette. When I am finished painting, I wrap the ice cube trays with unused paint still in them in a layer of wet newspaper, place them in gallon-size zippered plastic bags, and then put them back into the cake pan, being sure to seal the lid by pressing out the air. Storing the tray in the refrigerator will keep the paint fresh for months; but don't let it freeze!

⬆ Arranging your basic colors on the palette

Arranging Colors on the Palette

The arrangement of colors on the palette is designed to keep the cool colors away from the warm ones during the mixing process. The divided ice cube trays help isolate the colors until I mix them on my palette (the bottom of the cake container). It's important to mix your acrylic colors on a white, waterproof surface, so the color of the mixing surface doesn't influence the paint color or absorb moisture from the paint. I cut a piece of

$^1/_8$" (3 mm) -thick white Plexiglas to fit the bottom of the clear plastic cake containers. An inexpensive, white plastic kitchen cutting board will also work. I also use white foam picnic plates, which can be thrown away (though this isn't the most eco-friendly option). I use a spray bottle filled with water to keep the acrylic paint in the ice trays from drying out.

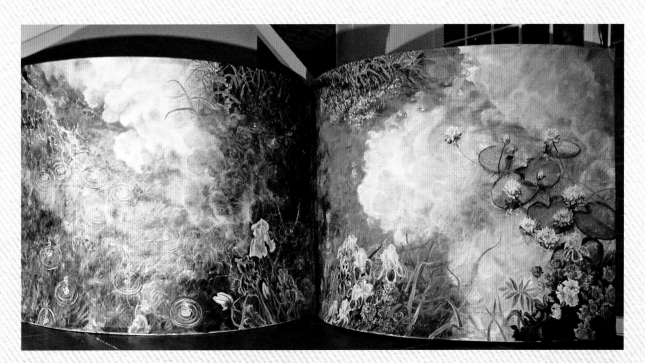

⬆ *Annie's Spring*, Window Well series; acrylic on shaped canvas on steel frame, 3' x 7' x 24' (0.9 x 2.1 x 7.3 m)

Painting Surfaces

Acrylic paint is compatible with a wide range of traditional and nontraditional painting surfaces. Primed canvas, wood, and paper are common painting surfaces for acrylic, but it also works well on unprimed canvas, silk, glass, and plastic. The paint itself, when dried in thin sheets, can be used as decals and transparency transfers from printed materials. Acrylic paint also acts as transparent or opaque glue for collage techniques.

Acrylic paint is a plastic material that stretches without cracking. I use acrylic on my large, shaped canvases, which have to be restretched each time they are moved. Acrylic paint has a nice affinity with raw rag canvas (canvas that has not been primed). When watered down, the acrylic acts like watercolor paint and soaks into the canvas, similar to the way watercolor paint spreads over watercolor paper.

For my traditional paintings, I use stretched primed canvas. Commercially made stretched canvases smaller than 36" (91.4 cm) are usually more cost-effective than making them yourself. I brush the already primed commercial canvas with one heavy coat of acrylic gloss medium. To make the surface even smoother, I softly sand the canvas with #150 grit sandpaper. For paintings larger than 36" (91.4 cm), I make my own canvas panels with wood stretcher bars. For shaped canvases larger than 12' (3.7 m), I use a custom steel frame to support the work.

I recommend beginning painters use tempered ¼" (6 mm) Masonite hardboard found at any lumberyard. The tempered hardboard is stronger. The board comes in 4' x 8' (1.2 x 2.4 m) sheets, which I have cut down for me to 24" x 30" (61 x 76.2 cm). I then apply two coats of white, semigloss acrylic exterior house paint, using a fine-nap paint roller. The smoother the surface, the easer it is to attain fine detail. Renaissance and Baroque painters spent weeks applying and sanding layers of rabbit-skin glue and gesso primer on their canvases and wood panels. The inexpensive hardboard will provide the smooth painting surface desired by the old masters! If you find that you want a more-textured painting surface, use the rough side of the hardboard or add fine sand to the primer paint. You can also glue stretched canvas onto the board.

Be sure to use a large canvas or Masonite board—at least 24" x 30" (61 x 76.2 cm); a large canvas size makes painting the smaller details easier. The bigger the canvas, the better—even a human-size canvas is not out of the question.

Brushes

When asked "What is the most important brush you own?" I usually reply, "my finger." Artists finger paint more often than you would think—don't be afraid to get your hands dirty.

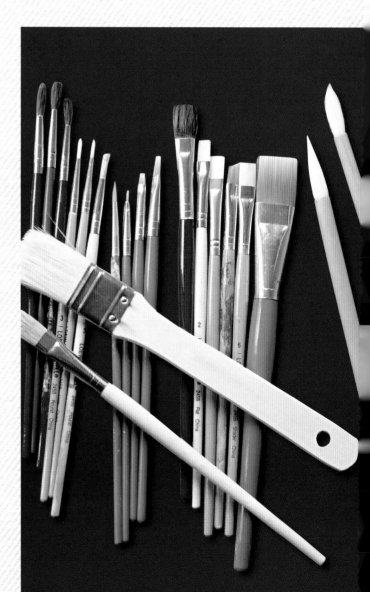

➜ You don't need to buy expensive brushes; look for economical assortment packs of brushes sold at major hobby stores.

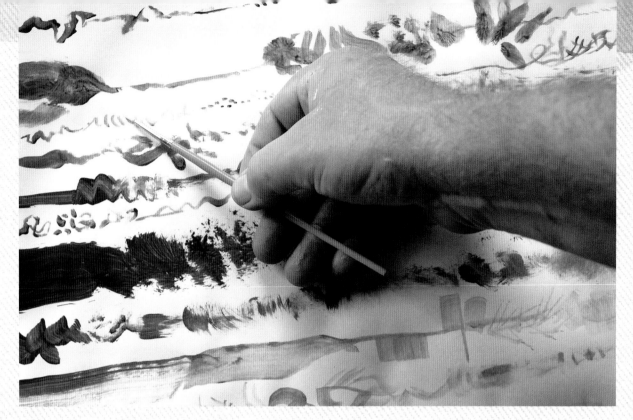

⬆ Hold the brush in your subordinate hand to create many different brushstrokes.

If you are just beginning, buy a large hobby pack of assorted brushes, which usually costs less than $10. These inexpensive packs contain twenty or more flats, rounds, and liner brushes made from hog, camel, or synthetic sable hair. Experiment with each one of them. Use your subordinate hand, not your dominant hand, and hold the brush in some other manner than you would hold a pencil; you want to lose control. Your dominant hand has been trained only to write, whereas your subordinate hand has the capacity to make many more visual notes through its lack of control.

Try to make thick and thin lines by rolling the brush in your fingers. Press the brush hard against the paper and see what happens when it starts to run out of paint. Saturate the brush with water and then dip it into the paint. Try to create curvilinear broad bands of color or fine lines by moving your arm, not just your wrist. As long as you don't try to hold the brush in your writing hand, you will come up with a very good idea of how each brush works and why it is designed the way it is. You will come up with more realistic brushstrokes. Even holding the brush in your toes creates wonderful, amazing strokes, compared to what you would create with your limited dominant writing hand.

One full hour playing this game will create many different visual possibilities that can be transferred to your dominant hand. Lose control, so you can learn to visually dance again, as you did as a child.

tip

Always keep the brushes you are using in water until you clean them! Acrylic paint dries fast and will quickly ruin a brush.

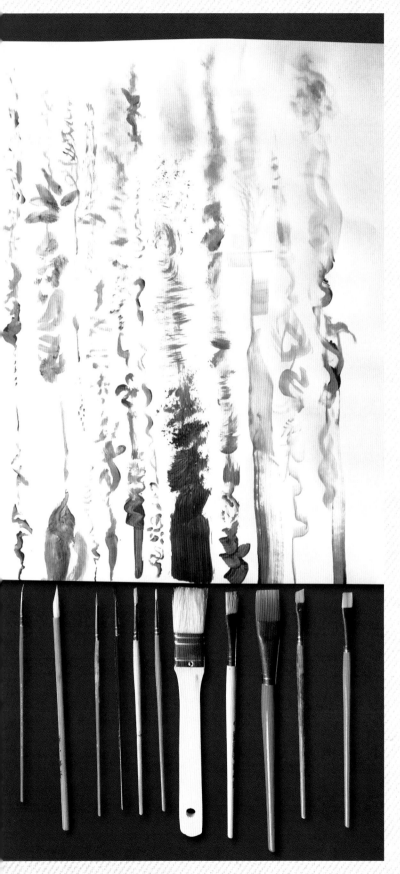

Brush Types

Stiff hog-hair paintbrushes are good for applying thick paint and for dry-brushing (scrubbing with very little paint). A good dry-brush technique looks like you used an airbrush. Soft camel-hair brushes work well with watered-down paint washes. Synthetic sable-hair brushes hold more paint than camel hair; they work well with washes and are easily loaded with raw paint for detail work and blending. Flat brushes scrub, blend, and fill shapes easily. Round brushes create lines, dots, and small fractal-like shapes. Long, soft, round sable- or camel-hair brushes can carry a lot of paint for long thick and thin lines.

TOOLS AND TECHNIQUES

Much of my teaching and personal art revolves around finding better and faster techniques to get the job done. To do this, you have to give up control and a little of your ego as an artist to gain more realism and creative spontaneity. Let the painting paint itself. At first, try not to overcontrol the paint to the point where accidents will not happen. Become a playful participant and an inquisitive observer looking for a new idea or direction in the painting process. Remember that your job as an artist is to evaluate what you have done and look for a direction that is better than your initial idea.

Art is a process that evolves on the canvas more than in the head. Spontaneous actions and accidents open new windows of opportunity. Most artists agree that they find more important techniques and ideas through fixing their mistakes than through researching other artists' work. If you become too careful, you will not grow.

◐ **This basic brushstroke exercise demonstrates the many kinds of brushstrokes that can be made by individual styles of brushes.**

Using Tools to Create Texture

A painting tool is anything that will make a mark on your canvas. I like to find many of my painting tools in nature—I go directly to the source. If I want to understand how a tree leaf is to be drawn or painted, I will cover the leaf in paint and press or stamp it onto a piece of paper to see what transpires; let loose and experiment. Using unusual painting tools can give you new ideas for mimicking textures.

↻ Stamped leaf

↑ Stamped grass

⬆ Experiment with crumpled newspaper; its shape mirrors nature's fractal components. Brush a medium coat of different colors of paint on the crumpled paper and stamp the paper onto your canvas. Use uneven pressure when stamping, and rotate the paper so you use all sides. The resulting marks reveal visual elements of vegetation, rocks, mountains, and even rough seawater.

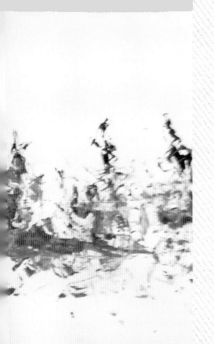

To create the snakeskin texture, I rolled a pinecone covered in paint on the paper. Dipping a pine-needle branch in paint created grasslike strokes. Cedar needles stamped the red leaves. Dipping old twigs in paint and using them like ink pens mimicked real branches, along with the tree trunk.

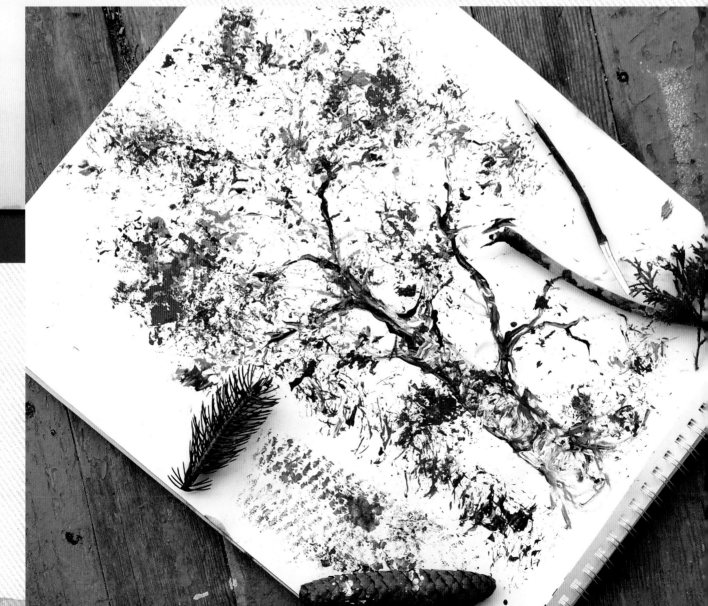

Rubbings

To make a leaf rubbing, place a sheet of thin paper over the leaf and rub the paper with a flat soft-charcoal drawing stick. The charcoal drawing stick will pick up the textures of the leaf and create a detailed charcoal blueprint for reproducing it.

You can also experiment with dry chalk pastels. First, choose a few colors that will mix together to make the overall color of the object to be rubbed. Apply each color individually by lightly rubbing it across the paper, while pressing the paper against the object. Finally, use black charcoal or chalk pastel to bring out the shadows and contrast. A little experimentation with the various color layers can create a fairly realistic rendering of the object. This exercise can provide invaluable information on how to layer paint to create a realistic image.

➲ Tree bark rubbing using three pastel colors plus black

↻ Rock rubbing using three pastel colors plus black

↺ Tree bark rubbing in black charcoal

 Wood fence-board rubbing using four
pastel colors plus black

 Grass rubbing

 Two-color leaf rubbing

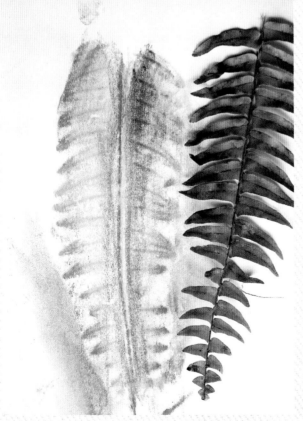

4

THE TRANSFORMATIONAL PAINTING PROCESS

It's time to start painting, to jump off the cliff and find your art wings on the way down. You will learn to fly with this first painting exercise. All you have to do is believe that you have the necessary tools and to shut down that ever-present critic.

Painting is like baking a cake. To make it, you first have to gather the ingredients, which, even in combination, don't look or taste like a cake. Even after mixing the ingredients and pouring them into a pan, you're still short of having something that looks like a birthday cake. But, put the pan in the oven and when it starts to rise, you can see that a birthday cake will be possible. Once the cake has cooled, and you apply the icing and light the candles—voilà, you have a birthday cake! Don't let the self-critic ruin any the stages of this marvelous process.

➔ *Annie's Spring* (detail); oil on canvas, 36" x 48" (91.4 x 122 cm)

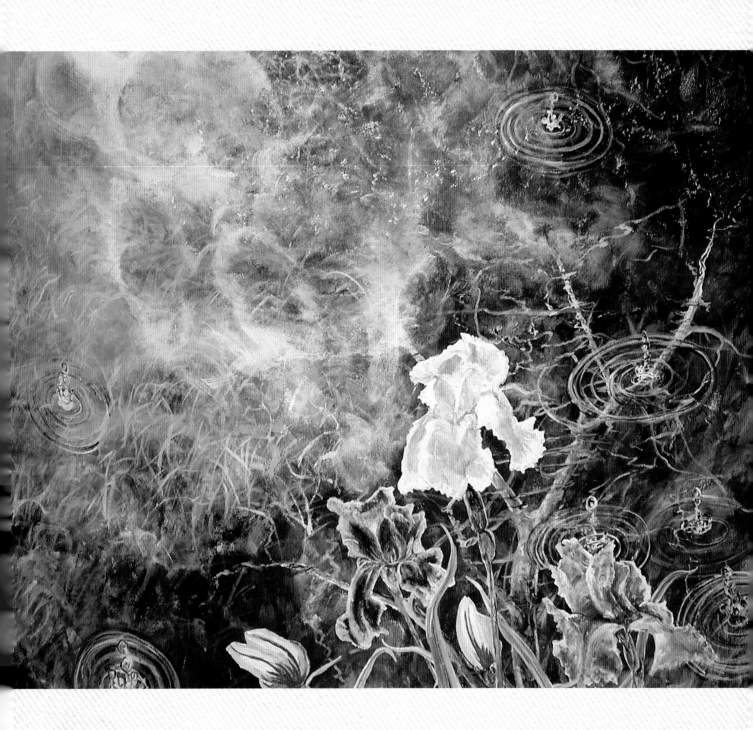

CHOOSING THE SUBJECT

Before you begin painting, choose an image to use as your subject. The best subject to paint in the beginning is a landscape with complex textures, colors, and shapes in the detail. Choose a landscape that you are passionate about but that also scares you because of its extreme complexity. Most inexperienced painters do not realize that the more information a subject holds, the easier it is to paint. Minimalist images with simple forms, such as dark silhouettes against a sunset, are difficult to realistically re-create.

Avoid choosing a subject that includes people or man-made objects—we are all experts when it comes to human faces and can decipher very subtle emotions revealed by a mere fraction of an inch of movement in a lip or an eyebrow. This means that our personal critic is very strong when evaluating paintings of people. To learn, you need to shut down the critic, and some students find this nearly impossible to do when dealing with the human figure for the first time.

Use a photograph of your landscape, rather than the real thing. Unlike a real landscape, which visually changes over time, a photograph provides a constant, unchanging subject. Your photo should be clear, sharp, and at least 8" x 10" (20 x 25 cm) or larger in size.

Using a photo also allows you to place it close to the canvas, so that you can see your subject and the painting at the same time. Positioning your photo in this manner is critical, because the average person has only a sixth-of-a-second visual memory of shape, angle, and curve. If you turn your head away from the subject matter, you lose it. Positioning your photo in the same field of view as your painting circumvents the lack of visual memory. With practice, your visual memory will become better.

➔ Collage of students' first-time paintings

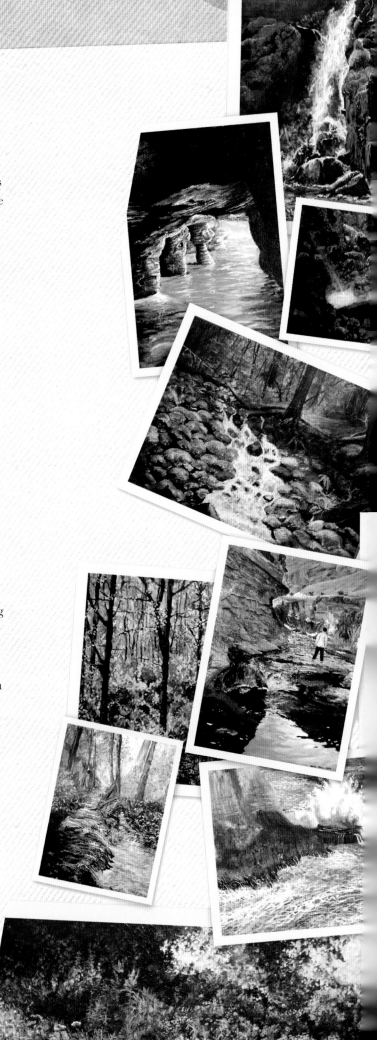

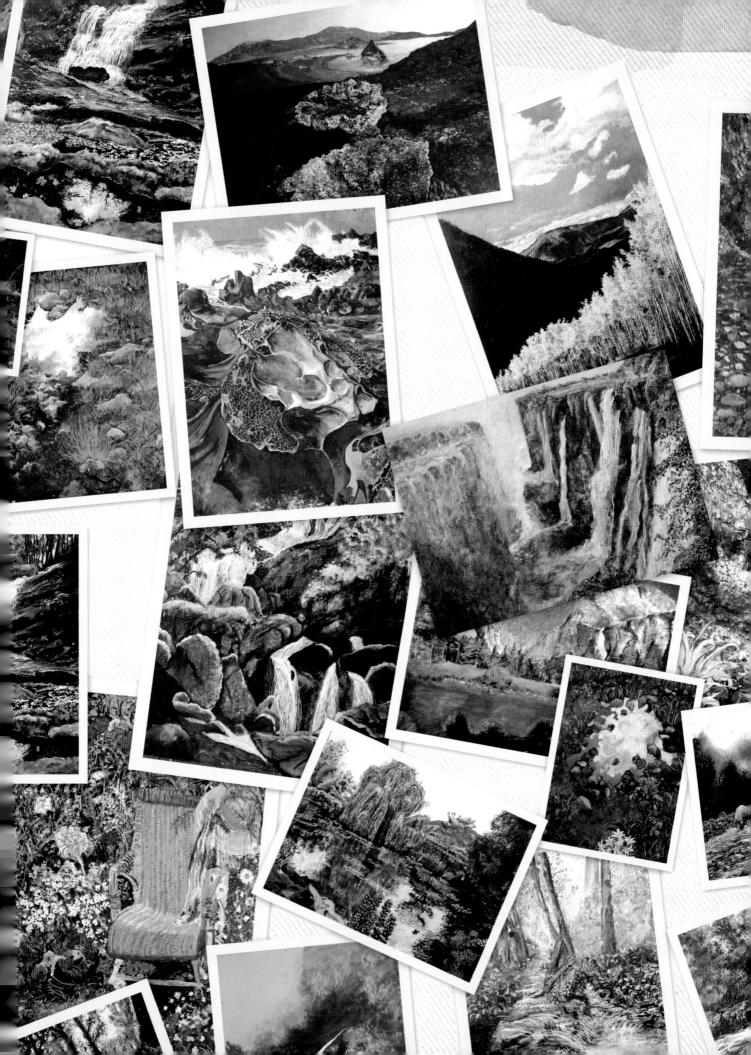

Measuring the Elements in Your Painting

Measuring the width and length of the elements in the photo and transferring them to a much larger canvas can be challenging for beginners. Using a canvas with a similar length-to-width ratio as the photo can be helpful. If the length-to-width ratio of the canvas is consistent with the photo size, you can use the sides of the canvas as a measuring device.

You can also use the small elements in the photograph as increments of measurement, much like inches on a ruler. For example, the width of a small rock in the photograph can be used to measure the height of a tree in the photograph. The tree might be fifteen rocks high or a waterfall five rocks wide. To get the measurement of the small rock, copy its length or width onto a piece of paper. Use this dimension as a measurement that will be constant throughout the photograph.

Using this same technique when creating a painting that's larger than the photograph allows you to accurately measure the objects in the painting and keep them in proportion. That small rock measurement will always be in proportion to the other elements in the painting. Once you determine how big the small rock is going to be in the larger-format painting, you can determine the right proportion for everything else, as long as you use that rock's width or length to measure every other element in the larger painting.

Here's an example: Place the paper with the rock measurement parallel to the width of the photograph and note how many rocks make up the width of your photo—let's say it's thirty rocks wide. Now, measure the width of the larger canvas with a ruler and calculate one-thirtieth of that measurement; your answer will be the size of the rock in the larger painting. Once you have determined the correct size of that rock, you can measure everything in the larger painting correctly using the length or width of your rock as your ruler.

This measurement tool ensures that all of the elements in the painting are in proportion to each other, because the size relationship never changes between the rock and every other object in the painting. The smallest element in a photograph or painting will always make a good ruler to judge proportion.

Don't trust your eyes to measure the width or length of the photo or painting elements. Seasoned artists always measure elements against one another because they know that combinations of color, shape, line, and value can create optical illusions. For example, a black square and a white square of the same size do not look the same size—the white square will always look larger. Your ability to measure with your eyes will get better, but always check your measurements against the elements in the painting or its perimeter.

CREATING THE CHAOS

The first step in the painting process is to create a complex, random, multicolored chaos of myriad shapes less than ¼" (6 mm) in size—the result will look similar to the pixels in a digital image or even the woodland camouflage used by army personnel to disappear into the foliage. These random pixilated shapes are your visual alphabet—the basis for creating your painting. However, unlike the process of using verbal letters, which are placed in tight, predictable sequences to form words, the process of using a visual alphabet is akin to randomly scattering millions of very small letters on a canvas and looking for words and even simple sentences that appear accidentally.

Once you have created the chaos, you will learn how to adjust its color and value to fit your subject matter—in other words, you'll learn to control the chaos.

Applying the Paint

Place your canvas on a horizontal, protected surface, such as a table or the floor. Now, close your eyes, raise your right hand, and say loudly that you are going to act like a four-year-old! I am four! (A little jazz music doesn't hurt either!)

Open your eyes, and then open all of your paint lids. You'll find that each has a small application nozzle in the cap. Squeeze the paint bottle slightly and tap it onto the canvas or board. A raindroplike pool of paint will appear. Do not squeeze too hard—you'll apply too much paint. Let the lid of the bottle drag a little as you apply the paint in a furious, fast, and spontaneous manner. Change bottles every five seconds. Put a bottle in each hand.

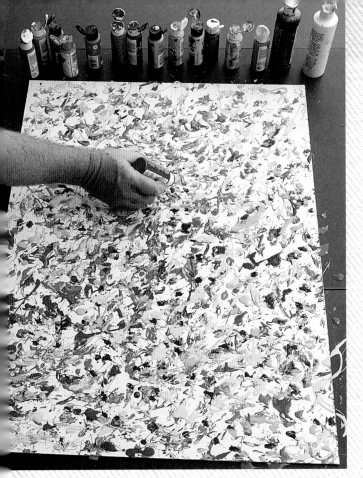

◉ **Applying the paint**

tip

Try not to take more than ten minutes for this step.

Do not stay in one area; do not place the drops in equal lines; and do not create equal-size drips, or space them equidistant from each other. The critical left hemisphere loves this type of control! You learned to shut down the creative right hemisphere when you learned how to write, so you might feel uncomfortable applying the paint in an uncontrolled manner. But with this process, you want to turn on your creative side and shut down the critical side of your intellect.

Apply the paint to the edges of the canvas—there are no margins. Use a lot of white and just a little of the black paint. Let some of the white canvas show. Do not make lines or throw the paint. You are trying to make a chaos, which, by definition, has no recognizable pattern—you are not making an abstract expressionism image that conveys emotions.

➔ **The finished paint application**

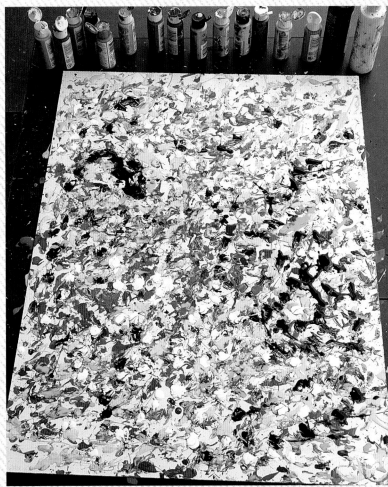

Turning the Paint Drips into Pixels

While the paint is still wet, loosely crumple two pages of newspaper in your hand so it looks almost like a rose with petals. Now, lightly dab the paper onto the painted canvas; the paper's loose curvilinear triangles will transfer onto the canvas. Avoid pressing the paper too hard—it will flatten out and smear the paint into a brown blob. It's important to use a light up-and-down motion.

Change the paper frequently. If you use the paper too long, it will become loaded with mixed paint and you'll print brown, muddy colors. Change your paper at least five times for a canvas this size. Staying in one place too long will also turn your colors brown. Do not drag or smear the paint. Keep a lot of white background showing.

Take no more than about three minutes to perform this process; if it takes longer, you are probably overworking the painting. If you have overworked it, let the paint dry, add the colors needed to make the painting crisp and detailed, then use the crumpled newspaper again. Don't worry—it's only paint and can be easily fixed.

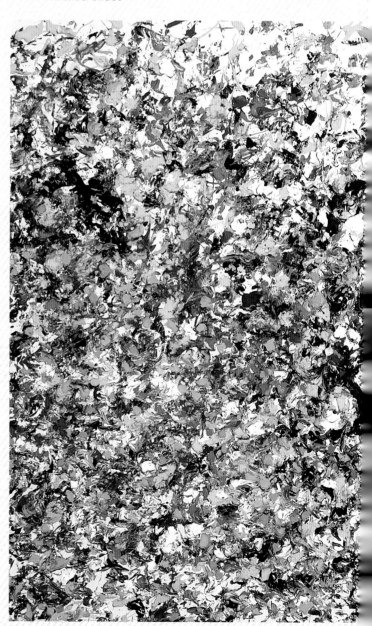

⏻ Finished chaos

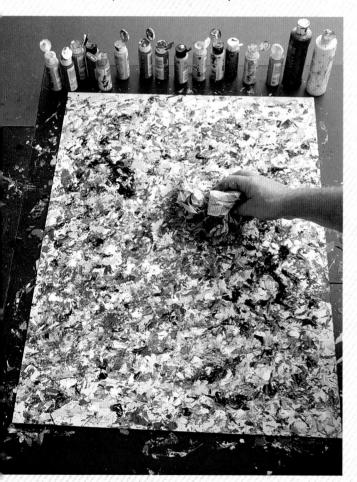

⏻ Use crumpled newspaper to stamp pixels/fractals into the paint.

DISCOVERING THE TRIANGLES

Our visual pattern-recognition centers break down the chaos into basic curvilinear triangles. Squares, rectangles, and lines are hard to see, but triangles readily show up. If you tossed 100 pennies on the floor, the basic patterns revealed are the circle shapes of the pennies and triangle shapes created by the spaces between the pennies.

In this section, we will be looking for triangles in the painted chaos that correspond to the triangles in the photograph.

Seeing the Triangles

Look at your photograph and squint your eyes out of focus—or take off your glasses if you wear them—to create a blurred vision of your photograph. The detail should disappear and you'll see mono-colored blurred shapes in the form of large and small curvilinear, ragged-edge triangles, almost like the wrinkles in your clothing. Play with your focus until you can break down the detailed photograph into simple triangle shapes.

Make a color copy of your photograph, or cover it with a piece of clear plastic, and draw the curvilinear triangles onto it. You can also try using a black-and-white copy of the photo, to see how the value differences create very basic triangle structures.

Applying the Triangles

You'll use transparent paint to reproduce the triangle shapes in the photograph on the canvas. To make transparent paint, just add gloss acrylic medium to your craft paints. You'll find that the paint looks a little milky at first, but it dries transparent. Use gloss medium; matte medium is not as clear when it dries.

A good rule of thumb is to add three times as much acrylic medium to the paint as you think you should. It's better to put down a few coats of transparent paint to build up the color than to use paint that is too opaque. Periodically, apply a clear coat of the acrylic medium over the entire painting. The layers of clear coat let light into the painting, creating vibrant, more-realistic color. Unlayered opaque acrylic paint dries chalky and flat—which is fine for a wall in your house but doesn't work well for creating a three-dimensional illusion. Make sure the underpaint is completely dry before applying the clear coat; if the paint is still wet, you will erase your work.

Now, reproduce one of the larger shapes from the photograph on the multicolored chaos surface of the canvas. Because your blurred vision has simplified the image, the colors of the soft, cloudlike patterns and shapes are not hard to determine. Also, because the blurred image contains no detail, it will not be hard to paint. As you paint the triangles, however, you'll notice that roughly 75 percent of the detail magically appears from the chaos peeking through the transparent paint. This means that, once the basic transparent shapes from your blurred-vision photo have been transferred onto the canvas, your painting will be approximately 75 percent finished!

Painter's Visual Language

The painter's visual language is a familiar one—you use it daily. You were an expert in verbal communication before you learned to read and write. Likewise, you were a visual expert before you learned to draw, paint, and sculpt. In school, you learned a verbal alphabet that closely resembled the attributes of speech. This book will give you a visual alphabet (chaos) that closely resembles the way you see.

You just have to see the curvilinear triangles in the subject. The more you try, the more you will see (this is how you learned to see as a baby). People who have had strokes in the left hemisphere of their brain experience the pixilated sight of the right hemisphere (chaos) and have to relearn to see the curvilinear triangles. Because you have already done this as a baby, it is easy to relearn.

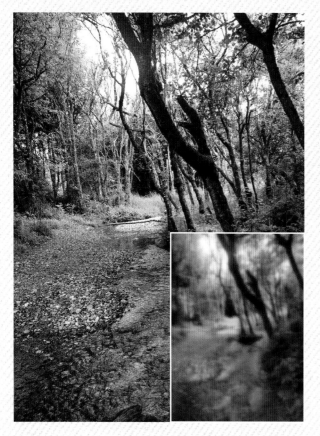

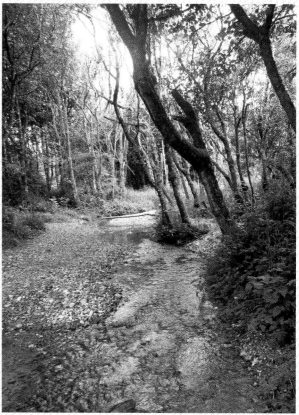

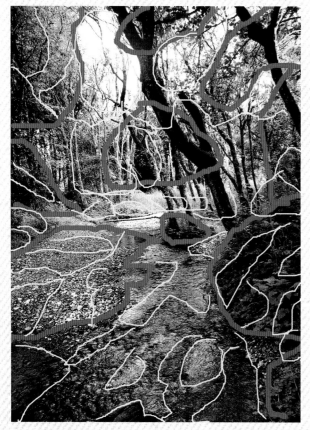

Photograph of the stream. Seeing the photograph with blurred vision.

Creating a black-and-white photo of your subject can help you see the triangles.

The red lines are the primary curvilinear triangles; the yellow lines are the smaller secondary triangles. In the process of turning this photo into a painting, we will use a total of five incrementally smaller sets of triangles. We'll be looking for the other three sets as the painting gets more detailed. Don't worry—your triangles will be excellent.

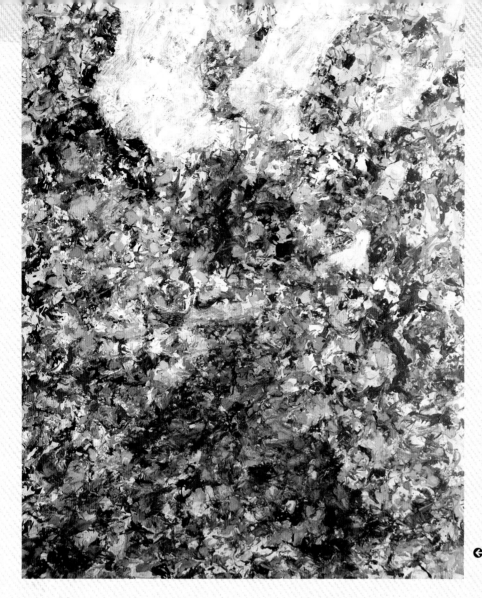

↩ Reproducing the main
curvilinear triangles
on the chaos

Stay Transparent

Be sure to add enough medium to make the paint transparent; you want to be able to see the chaos through the paint, not to cover it. If you cover up the chaos, you will lose the alphabet building blocks of visual literacy.

This is a critical stage in the painting process. Once you start trying to see the subject in the painted chaos, the left hemisphere critical-thinking part of the brain becomes very angry at this uncollated messy chaos and will generate a tremendous need to erase the chaos and place objects from the photo over it. This is like a right-hemisphere-dominant creative person erasing words and replacing them with objects.

That third intellect—the critic—needs to be shut down, so that the creative side can turn back on. Once you understand that the accidental curvilinear triangles actually create the detail in the chaos, the creative intellect will suddenly take over and want more. This is the critical stage of transformation, when the two intellectual voices become equal and truly start dancing with each other.

DISCOVERING THE ACCIDENTAL DETAIL IN THE CHAOS

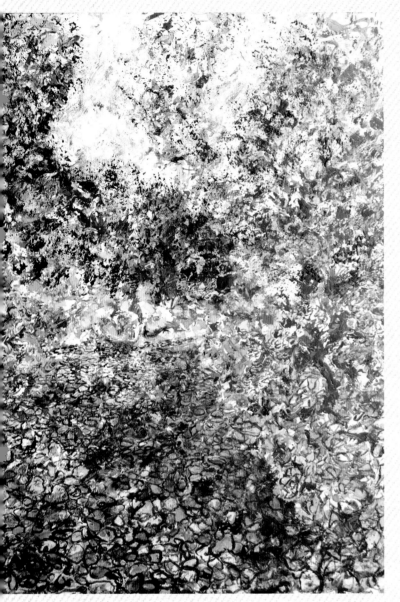

Seeing pattern in chaos is our specialty of developed sight. If you have ever played the visual puzzle game "Where's Waldo?," you'll recognize a similarity in the next step. You will be finding the "triangles, rocks, leaves, trees, and flowers" that already exist in the chaos and illuminating them. (You might even find Waldo's face!) You will discover the detail in the chaos—you do not make up the detail in your head and then put it on the canvas. Even accomplished artists know that reality is much more sophisticated than what their intellect conjures up. Let the painting paint itself!

Looking for Rocks and Leaves

Use a round, size 00 sable liner brush and black paint to outline as many rocks as you can find in the streambed and on the banks of the stream. Make sure that you are finding the rocks, not making the rocks. If you find yourself making a row of little black circles, you are not looking for the rocks—you're just making the critical-thinking sections of your brain happy; and when they are happy, your art suffers.

Leaves are illuminated in the same manner as the rocks. Pay attention to the overall shape of the leaves. They have small and large, thick and thin, shieldlike shapes, but many are angled and do not always show their full shape. The outline color of the leaves can be black in deep shadow and blue or dark green in the lighted areas of the plant.

↜ Looking for rocks in the chaos

tip

Detail is usually what you first see in the painting, such as the tree trunks, rocks, and leaves. But we always paint what is behind the detail first. The chaos paints 75 percent of the detail and provides a blueprint for adding the last 25 percent—in the same way that a chocolate cake influences the flavor of icing applied to the cake. The remaining detail is generally added near the end of the painting process.

➜ **A pot scrubber creates great leaves!**

Creating Dimension

Every three-dimensional object has a top, bottom, and sides. If your point of view is from above the middle of the object, you see its top. If your view is from below the middle, you might see the bottom unless the object is sitting on something. If you are looking from the left or right of the object's center, you see one of its sides. Although this explanation seems obvious, achieving the correct perspective in a painting can be difficult if you don't know your visual location in the image. Before you start adding tops and sides to your rocks and leaves, establish your horizon line and your position in relation to that horizon line.

Once the rocks and leaves have been outlined, create tops for your rocks by covering up the top black line with an opaque pastel color. To make an opaque pastel color, add white, instead of acrylic gloss medium, to one of your saturated colors. To keep the top edge of the rock sharp and create the illusion of a three-dimensional object, smudge the inner edge of the pastel line with either end of the brush. The bottom black line will look like a shadow. The top pastel line with the fuzzy inner edge will become the top of the rock.

For the leaves, randomly choose the side you want to lighten: front or back, left or right. To accentuate the leaves, use only random combinations of white and yellow for the pastel lines: these can be random applications of white and yellow mixed together and/or either white or yellow. Just as you did with the rocks, make the inner edge of the pastel line a little fuzzy. You can also add small, curvilinear leaves by pressing the point of a round, size 1 brush onto the canvas and slightly twisting it. Position your hand at different angles when making the leaves, so they don't all point the same way.

In roughly the center of the painting and farther up, the leaves are so small that you can use a pot scrubber to stamp them. To do this, place a thick layer of paint on your palette and dip the raveled end of a pot scrubber into the paint. Take care not to oversaturate the scrubber. Experiment on a piece of paper by lightly stamping the paint onto it until you get the desired effect. Once you're happy with it, apply the paint to the canvas, putting the white down first, and then the yellow. You can use this technique for all the very small leaves. Change the color or value to match the particular leaves that are in shadow.

⬆ Detail of the stream bed: applying highlights to the rocks

⬇ Detail: applying highlights to the tops and sides of the rocks

➔ The visual magic has started.

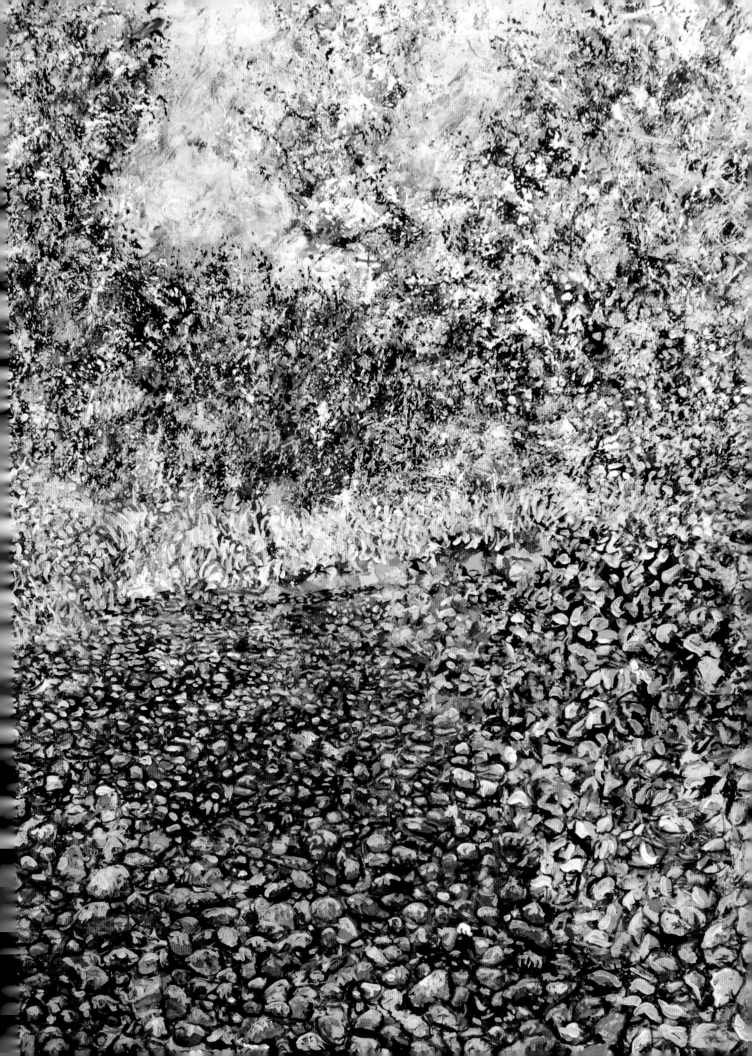

PAINTING THE TREE SILHOUETTES

Your critical-thinking centers have excellent abilities in drawing perimeters, especially solid black silhouettes. This part of the process will give the critical part of your brain a chance to work. You will use a type of control that is similar to writing but with a twist in the application of the line.

Hold a round, size 0 or size 4 sable or synthetic sable brush as you would normally hold a pencil. We are going to start painting the tree trunks on the canvas. Starting with the tree closest to you, paint a small section of its base with black paint. The result will look like a stump. Locate all of the other major trees bases in the painting that correspond to the photograph, taking care to measure them so they are located in correct proportion to each other and the edges of the canvas. You might want to look at a black-and-white copy of your photo to better see the tree branches.

If you make a mistake, use a damp rag to erase the tree stump. Because of the coats of acrylic medium, the canvas will be slick and the paint should erase easily. If you find later that you have to remove paint that has already dried, you can scrub it off with rubbing alcohol or just paint over it. The tree "mistake" could become a perfect tree, however, so you might want to keep it.

Painting the Branches

To add branches to the trees, start with the first tree trunk and make a small mark where the main tree branches exit the canvas or disappear into the treetop or sky. It helps to tape your photograph to the canvas so that you can see both the tree in the photo and the tree you are painting. Load the round brush heavily with black paint. Place your hand holding the brush against the canvas, which is either lying flat (on a table or the floor) or vertical (on an easel)—you choose the comfortable position. Do not take your hand off the canvas. Now, touch just the very tip of the brush to the canvas. Start at the exit point of the main branch, and move your whole arm—not your wrist or fingers—concentrating on duplicating the curvilinear nature of the branches. You will find that all you have to do is press harder on the tip of the brush to make a thicker line. I cannot emphasize enough the importance of not taking your hand off the canvas and not moving your fingers.

When painting the branches, keep in mind that they are not straight. Let's use your body as an example. Your legs, arms, hands, and fingers branch out from your body like branches from the trunk of a tree. Just as there are no straight lines on your human branches, there are also none on a tree. In fact, you cannot find a straight line in nature at all. So, move the brush slowly, with a slight tremor or palsylike movement in your arm, and you will make very realistic trees and branches.

When your line has connected with the stump, move on to the next tree and do the same thing. Once the primary branches are finished, paint the secondary branches. Continue painting smaller and smaller branches, until you have gone down five increments. Paint all of the trees black, even the light ones.

tip

If you keep making straight lines, it is because your dominant hand was taught to only make marks associated with writing and printing. Your subordinate hand, however, can still make thousands of marks. This is because our subordinate hand still has a built-in, 10,000-visual-note keyboard that was not destroyed by learning to write. Your subordinate hand is still four years old! In this technique, the subordinate hand will teach the dominant one how to paint and draw. The dominant type of hand control will be needed only in the last stages of the painting.

→ **Adding the tree-trunk silhouettes**

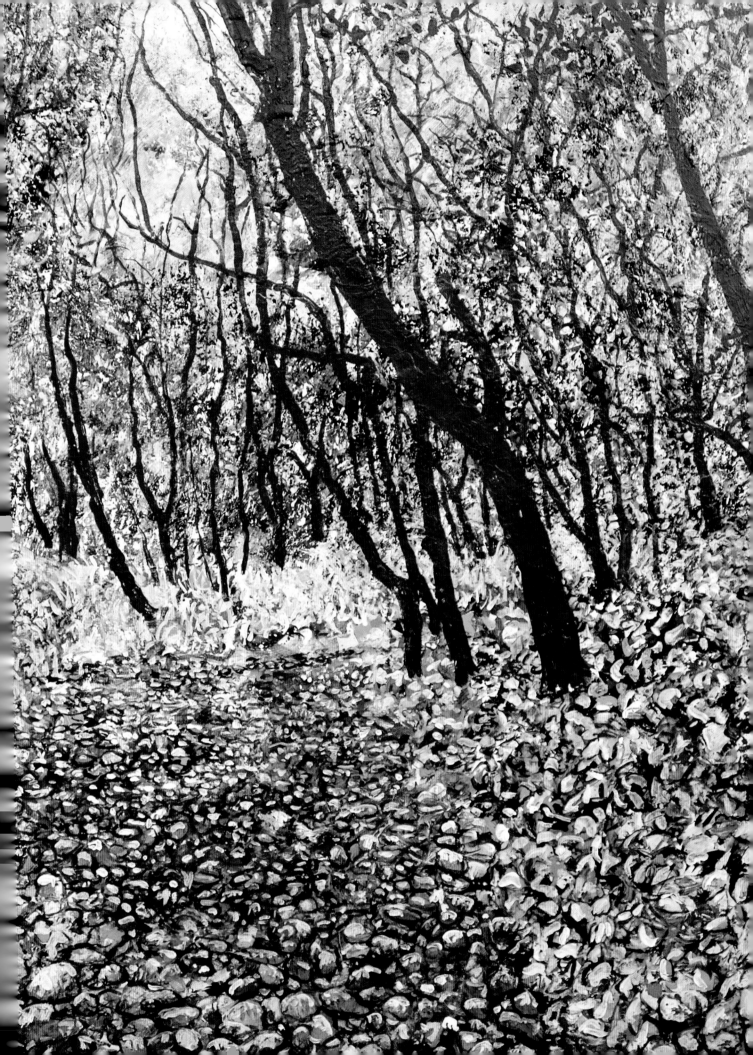

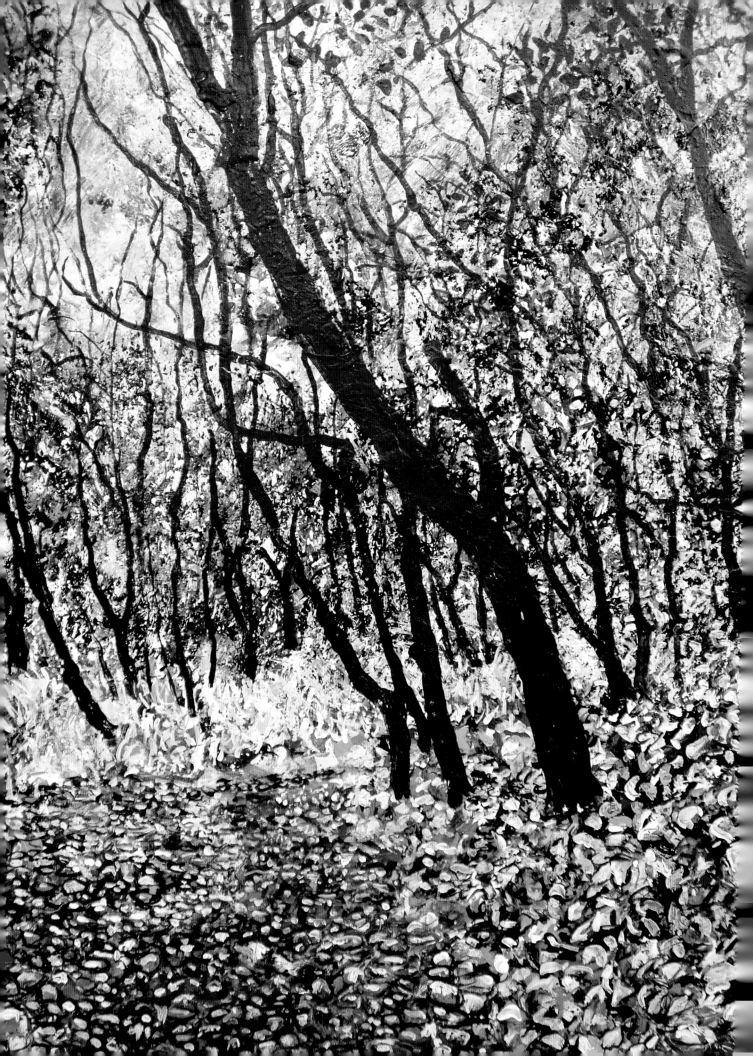

PUTTING LIGHT INTO THE FOLIAGE

Mix glossy acrylic medium with acrylic paint and you have transparent paint, or in art terminology—a glaze. Using a glaze instead of opaque paint allows you to create a substantial range of colors. It also lets you push a color to its brightest, because the transparent glaze allows more light to reflect off the white underpainting and through the layers of transparent color paint, giving the area an inner glow. Opaque paint absorbs and traps light, reflecting less back to the eye. When you see a painting that includes flowers, bright fall colors, or colors that are particularly brilliant, the artist has usually used white paint first and then applied the local color as a glaze.

In this step you will paint a yellow-and-blue-green glaze on all the white-painted areas in the foliage. I generally start out mixing one part dark-value color (blue/green) with five parts light-value color (yellow). To make a glaze, I add five parts acrylic medium to one part paint. Your painting will start to glow with light.

APPLYING THE SECONDARY TRIANGLES

Now you need to apply the local color and value. Go back to your photograph and find the secondary curvilinear triangles. These smaller triangles will either be shadows or highlights. Follow the same rules you used for the primary curvilinear triangles to reproduce the secondary triangles on your painting.

Painting the highlights in the foliage with glazes.

Applying the secondary triangles (yellow lines).

To make a shadow glaze, add a little black or dark purple to your local colors. For the highlight glaze, mix the local color with acrylic medium. Avoid trying to make a highlight glaze by mixing white with acrylic medium; your glaze will be too opaque. Use only the local color. If you need a brighter color for the highlight triangles, first paint strokes of white to match the shapes of the leaves, rocks, or grass, then let them dry before applying the proper glaze color. These shadow and highlight glazes give dimension to the objects in your painting.

When you find a triangle in the photo, note its basic color. The slight shadows in the brown beach rocks, for example, appear to be "cool" colors, such as purple and blue, so a little blue or purple was added to the acrylic medium for the glaze. The grass was already a "warm" color of yellow, so a thin glaze of blue-green was used to create its shadow triangles. The trees and foliage on the right received a more saturated blue-green glaze. The very dark shadows were created with a combination of black and blue-green glazes.

Note also how the triangles in the beach rocks zigzag into smaller triangles as they recede into the background of the painting. This kind of configuration will always give an illusion of depth. Do not become frustrated if your curvilinear triangles do not quite match the photo. Your triangles will create depth if they overlap and become smaller, as they do in the foliage on the right and the yellow grass on the left of the painting.

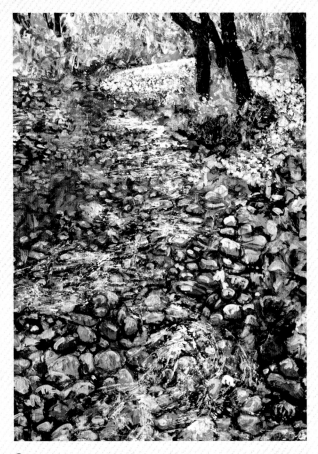

↥ **Applying the secondary triangles in the stream detail**

tip

If you use a dark glaze over a light one, you can make the light color come through by scratching off the dark layer with a knife or carpenter's nail. I used this technique to make small leaves, branches, and grass blades, which are difficult to create with a brush. The yellow grass and the foliage in the painting are created with this technique.

➔ **The secondary triangles painted with glazes**

ILLUMINATING THE DETAILS

For the rest of the painting, you will be using very small brushes: rounds in sizes 00 to 2 and flats in sizes 2 to 3 in sable and hog hair. Tell the impatient critic that the painting will go faster with these small detail brushes than with larger ones.

Begin to illuminate, or paint around, the detail that starts to accidentally pop up in the painting. When laying down a shadow glaze, use a wet rag to wipe off some of the glaze and bring back some of the detail. Use a wet cotton swab to bring out lighter leaves in the dark foliage. This technique creates realism and contrast in the individual small-triangle elements of the painting. As you paint, continue to ask your intellects the first three of the four questions found on page 80.

After you apply the warm and cool green glazes in the tree canopy, stamp the sky back into the trees with the pot scrubber. I use white paint first, let it dry, then add a thin glaze of sky color over the white. To make the white ripples in the water, I drag the pot scrubber ever so softly in a zigzag motion. The small white-rock beach in the center of the painting was made by lightly stamping white paint with the pot scrubber, letting the paint dry, and then going over the area with brown, purple, and blue glazes, and with a little more white stamping on top—similar to the technique used to make the small leaves. When using any tool, brush, or even the pot scrubber, remember to ask yourself the first three key questions, so you don't overuse that tool or technique.

From this point, the painting's realism is based on your finding successively smaller curvilinear triangles. You have the ability to see triangles; you now just have to develop the patient attitude to do it. Both the critical and the creative intellects have to be trained to be patient.

Continue to apply the tops, bottoms, and sides to all the curvilinear triangles wherever they need it. For the example, I used white for all of the detail, except for the trunks of the closest trees. (The white detail will later be glazed over with a local color.) Much of the detail your eyes recognize is on the perimeter of the triangles. You can leave the body of the curvilinear triangle abstract and still create an illusion of reality.

↻ All the curvilinear triangles in the painting now have tops and sides.

⬆ Putting light areas in the trees makes them stand out.
➡ Dry-brushing the dark tree trunks adds realism.

Making the Trees Stand Out

Paint a thin, uneven coat of pure white on the black trees in the background. Determine where the light is coming from in your painting, and try to keep the white on that side. You can sharpen the handle end of your round size 00 sable brush and use it to scratch through the white layer of paint, drawing contour lines around the trunks, just like the wrinkles on your wrist. Contour lines create the illusion of roundness. Vertical lines will make the bark texture of the tree. It's also time to add the smaller white branches, using the same technique you used for the black trees.

The trunks of the larger trees will be dry-brushed. For this, we'll use stiff hog-hair brushes in a light scrubbing action. Put a very tiny bit of white on a round, size 0 or 1 brush. Take most of the paint off by brushing it against a paper towel until it's almost dry and then lightly paint the black trees. If the paint is going down like chalk, you have the right consistency. Notice that the white only adheres to the raised textures formed when

you created the chaos. The white paint stands out on the black trunks, creating a barklike pattern. Have fun experimenting with this technique. When you've finished with the dry-brushing, use a fine detail brush to create highlights, as you did with the smaller, white trees.

Once the paint has dried, apply a coat of acrylic medium over the tree trunks and let it dry. You now can play with applying colored glazes over the dry-brushed paint. For example, I like to use a green glaze on parts of the trunks to represent moss, but you can choose to try something different. Try to experiment with various warm and cool colors. Determine where the light hits the tree and use a warm color there. Apply a cool color where the shadow or dark side of the tree might be. Do not use brown until you feel it is absolutely necessary. You'll find that the cool- and warm-colored glazes visually mix into a brown color.

Highlighting the Ripples in the Water

Dip the pot scrubber lightly into white paint and drag the scrubber in a zigzag motion to create the ripple highlights in the water area. You can also use a piece of heavy aluminum foil that has been crumpled up then slightly flattened out to make a stamp for small water ripples. Use a wide brush to coat the foil with white paint, then press it onto the canvas. Be ready with a wet rag to erase any unwanted white paint. Once the paint has dried and another heavy coat of medium applied, paint over the white ripples with blue glazes. Note that not all the ripples are painted blue—some are left white to create highlights in the water.

Experiment with different colors of blue. For example, try mixing purple with the blue for darker ripples. As always, keep the glaze very transparent so the light reflects the white underneath the glaze.

Adding Highlights and Dark Details to the Foliage

Remember that most of the details are on the perimeters of the large and small curvilinear triangles. Contrast—the difference between extreme light and dark values—is a good tool for getting the eye to notice detail. The foliage on the left of the sample painting is an example of contrasting detail. By creating tops and sides through the addition of light or dark painted detail, you give shape and volume to the bushes and trees.

Painting the Highlights

To begin adding the contrasting light detail, look for areas in which dark and light edges come together. The edge of a light area is usually closest to your light source—the tops and sides of the bushes, trees, and plants facing the sun. To create the highlights, start by painting the plants, leaves, and small branches in white at the upper edge of a light area; make sure they extend onto, and are silhouetted by, the dark primary and secondary curvilinear shadows you put down earlier. Keep checking the photograph to find as many small structures as possible at the perimeter of the light and dark edges. Paint the detail white using a size 0 or smaller, round, sable liner brush.

Remember that you are trying to find the foliage detail created by the chaos and the underpainting. Blur your vision as you look at the photograph and you'll notice that, though the trees and bushes look like green clouds, the edges facing the sun or the light sky hold most of the detail.

Once the white detail has been added, paint transparent glazes over the detail. Use the photograph as a reference but also exaggerate the colors, with brighter yellows, greens, blues, and purples. You can tone those bright colors down if they are too bright by adding more paint to the glaze or applying a complementary color. Remember to keep the glaze extremely transparent, so the white underpainting reflects as much light as possible—these are your highlights, and you want them to be bright.

G Highlighting the ripples in the water

Painting the Dark Details

Painting the contrasting dark detail is the opposite of painting the light contrasting detail: you want to paint the small details that you see in the photograph with a darker color than the surrounding light area. I normally use black or purple for the dark details and later go back and add lighter leaves or color to the dark. Use the photograph to determine the colors to use and how dark they should be.

As with painting the highlights, look for areas where dark and light edges converge, focusing on the opposite, or bottom, sides from the light source. These dark areas are the shadow sides of the bushes and trees. The shadows will be silhouetted against the lighter bottom side of the objects. The dark detail emphasizes the transition between shadow and light on the body of the object being painted and creates the dark side of the object. Notice, for example, that as the treetops get closer to the bright sky, the branches look darker.

To understand this better, try this exercise: Standing outside, extend your arm straight down, then slowly move your arm toward the sky. Keep your arm extended straight, and don't take your eyes off your arm as it moves from your waist up to the sky. You will notice that, as your arm moves closer to the bright sky, it becomes darker, in contrast to the brightness of the sky. Treetops and branches are usually painted as darker silhouettes because of the bright background light.

Four Important Questions, Part 1

When you create the smaller triangles in the painting, the creative and critical intellects start working together. To develop a healthy dialogue between both intellects, ask yourself the Five Important Questions. (Four questions are listed here; the fifth question is discussed later in the chapter.)

1. The first question is for the critical intellect: Am I repeating myself? Am I doing something equal in spacing, dimension, shape, or line—creating a predictable rhythm in the elements of my composition? Am I using a technique too much? If so, mess it up!

2. The second question is for the creative intellect: Am I using the correct colors, values, and brilliance in the shapes I have drawn? Is my paint transparent enough to allow the chaos to show through?

3. The third question is for both intellects: Are the shapes in my painting the correct size and dimension, mirroring the proportions of the photograph or subject matter?

4. The fourth question is about creating the illusion of depth. Look at all the elements of the painting and ask yourself, "What is in the foreground, and what is in the background?" Elements in the painting have a natural place: they're in the foreground, middle ground, or background. Each element's place is created by its color, texture, shape, size, line, and value. Adjusting these elements within the painting creates a seamless illusion of depth.

tip

At this stage in the painting, it is important to get opinions from people who will honestly tell you what they think. Avoid asking those who won't give you a straight answer or will only say good things about the painting, for fear of hurting your feelings. Ask the four questions (above); those four questions are universal and can be answered by anyone, even children.

You need an outside opinion of your work because, when you work on a painting for a long time, it is difficult to make critical decisions about it. Every element in the painting starts to look equal; it's like saying a word over and over, until it becomes meaningless. To see the painting in a fresh way, you need to solicit other opinions.

Defining the Detail

To define the detail in the painting, start by asking yourself (and others; see Tip page 80) the four questions (page 80). Each area, object, and detail of your painting needs to be evaluated using those four questions.

When I looked at the photograph with blurred vision, I noticed that the sky in my painting needed lighter areas. The contrast between light and dark in the sky was not strong enough to create the illusion of light filtering through the trees. I used titanium white with a size 2 flat hog-hair brush, painting into the curvilinear areas of the sky using a combination of dry-brush and normal paint strokes to create light filtering through the trees.

As you work, keep looking at the photograph and your painting and ask the color and value questions. I gave the water multiple glazes of ultramarine blue, white, and black to give it depth and create the illusion of moving water. More dark glazes were added to create contrast.

I also added light reflections and ripples in the water. When I needed to put in a darker ripple, I used a mixture of one part purple or blue paint to three parts gloss acrylic medium. If I determined that I needed a lighter ripple or highlight in the water, I painted it with titanium white. When the paint was dry, I added blue glaze over the white so the white reflected the light. I also went over the water with the extra ripples and highlights, and in the process covered up some of the rocks in the water. I went back and repainted those rocks using the rock technique used at the beginning.

I also gave the upper parts of the trees edges more detail in their branches, using ultramarine blue and purple with equal amounts of acrylic medium and a size 000 round, sable liner brush.

⬆ **Defining the detail in the painting**

The gravel bar rocks in the foreground were too small in size to make the transition from foreground to background plausible. I made some of the rocks in the foreground larger to create a better illusion of depth. The larger rocks were made lighter to pull them forward from the darker middle ground stones. I also added smaller curvilinear shadows and highlights into the distant part of the beach with glazes of white and tan. Adding these incrementally smaller and smaller shadows and highlights creates a better illusion of depth in the gravel bar and defined the edge of the stream.

↖ Detail added to background trees and rocks

↑ Converging sight lines, focal point, zigzag, and overlap

↙ Spatial qualities of brilliant and dull colors

CREATING THE ILLUSION OF DEPTH

Most of the time spent on the last part of a painting is in adjusting its elements to create a seamless illusion of depth. Earlier, we learned that brilliant and warm colors come forward more than dull, low-value cool colors. I reversed that rule in this painting by putting dark, cool colors and shadows in the foreground of the painting and gradually going brighter and warmer toward the background. This type of color/value scheme gives the illusion that you are moving through a tunnel toward the light and works as long as the objects in the background are brilliant, smaller, and out of focus. I wanted to show in this composition that "art rules are made to be broken." Rules are predictable phenomena. By experimenting, you will find new rules that fit you, and your work will become uniquely powerful.

The illusion of depth is also created by:

- shapes that overlap and become smaller as they recede into the background of the picture plane (yellow overlapping lines in the photo, opposite
- multiple objects of the same kind that become incrementally smaller (trees)
- similar objects with sharp edges and textures that become smaller and slowly lose focus and detail (foliage and rocks)
- lines that zigzag into the distance (zigzag red lines in riverbed and gravel bar)
- any type of converging lines that point your eye toward their intersection

Converging lines act like arrows on a sign and create artificial vanishing points, similar to the way ceiling and floor lines in a long hallway converge to a point in the distance. When you drive down the highway, you'll notice that the road, the center line, and the telephone lines converge at a single point on the horizon. Similarly, when you draw the major and minor fractals on your photograph, you will normally see many of the lines converge at one point on the horizon line. In this painting, all the major sight lines meet at the bend of the stream—the painting's vanishing point. This is the exact point at which my camera was aimed.

The red lines are the converging perspective lines, which all meet at the focal point of the painting. When you look at the painting, your eyes instinctively follow the converging lines to their intersection, which creates realistic feelings of movement in your mind. I have seen people in a gallery walk toward a large painting and actually lean in the direction of its strong, angled vertical lines. A painting should make the viewer subconsciously dance to its composition.

A meandering river's curvilinear triangle shapes become smaller and smaller as the river snakes its way into the distance. Anywhere thick curvilinear triangle fractals become shorter and thinner, they give the illusion of depth. Notice that the blue and white ripples in the streambed also zigzag into smaller and smaller triangular shapes.

The Six Basic Compositions

To understand and navigate our world, our brain uses six basic visual templates or views. In art, we call these visual templates compositions.

1. Thirds Composition: The picture plane is divided into three unequal parts. Magazine and newspaper photographers commonly use this composition.

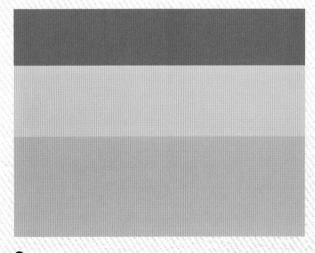

⬆ Thirds composition

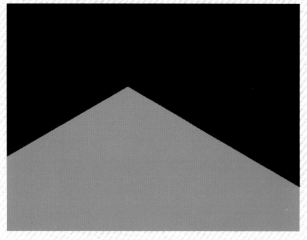

⬆ Pyramid composition

⬆ Circle composition

⬆ X composition

⬆ Composite composition

⬆ Zigzag composition

2. **Pyramid Composition:** This composition directs your eye to a certain elevated point and is used in portrait work to suggest power. It is also used to create space in perspective-based landscapes, bringing your eyes to a converging point in the distance, like a roadway disappearing into the picture plane.

3. **X Composition:** This composition is based on two converging lines that form an uneven X across the picture plane. Many landscape paintings are composed in this way. The landscape we are working on is primarily an X composition; it brings your eyes to a distant point. The trick is to keep your eyes from getting stuck at that intersection. You have to give your eyes a sight path to move around the painting. The X composition creates the illusion of traveling from foreground to background and creates a tangible reason to go there.

4. **Zigzag Composition:** The zigzag composition is composed of parallel triangles that become thinner and smaller as they recede into the horizon. This composition takes you slowly through the landscape into the distance, with each point of the small triangles illuminating a detail and encouraging the viewer to visually walk slowly in a prescribed path of discovery. This composition is used to create an illusion of very deep space.

5. **Composite Composition:** This is a complex composition that uses all of the first four basic compositions at once to gain as much depth and power as possible.

6. **Circle Composition:** The circle composition is difficult to use. The circle works like a target bull's-eye, drawing the eye's attention to the center, where, without an escape route, it can get stuck. A good composition keeps the eye moving across the entire composition for at least four revolutions and will always lead you from one element in the painting to the next before your eyes move off the canvas to the next painting. Every artist strives to create an extremely powerful composition that keeps the viewer's eyes traveling around the entire canvas for at least six revolutions. When an artist can create an escape route for the eye, the composition becomes powerful. Creating a spiral out of the circle, which leads the eye back to the starting point, is one solution.

AVOIDING TANGENTS

Our eyes always follow lines. When two lines meet, the intersection point stops the movement of your eyes, just like your car stops at a dead end. Normally, your eyes continually move and sweep the field of vision. Your mind directs your eyes constantly and does not like to be visually trapped in one spot. If your mind is placed in this type of position, it directs the eyes somewhere else—usually to another painting.

Use tangents only if it is your intention to direct and trap a viewer's eyes at a certain spot. Tangents are like punch lines in a joke; once a tangent is used, the composition is over—along with the viewer's interest.

Exterior tangents are objects in the picture plane that touch or end at the painting's edge (see the illustration below). To avoid creating an exterior tangent and forcing the eye to become trapped or fly off to the next painting on the wall, let part of the object go off the page, or place the object away from the picture's edge.

One of the reasons we use margins in writing is because it is easier for the eyes to travel to the next sentence. It would be very confusing if the letters began and ended at the edges of the paper.

⬆ **Exterior tangents**

↑ **Interior tangents**

Interior tangents work just like exterior tangents in trapping your eyes at one point, except that the objects touch the edge of a line within the picture plane, creating visual tension.

Tangents are not necessarily bad or good—they are just powerful visual phenomena that glue your vision to one place. If that is your intention, with luck and ingenuity, you can make it work. Beginners should avoid tangents, though, until they become more visually cunning.

ENDING THE PAINTING

Knowing when and how to end the painting is difficult. A painting is never truly finished. Painting is about asking visual questions, and for every question you can answer many more arise that that you can't answer. If this happens, it means that you are still growing and are not stagnant. A single painting will always be in flux throughout your lifetime. When you grow, it also changes.

If you stay too long on a painting, you can work it to death; put it aside until you see it differently. When I finish a painting, I am looking for a partnership between my original idea and the new concept revealed during the act of painting. That new idea or surprise is usually where the most power comes from. I try to showcase that new idea to its limit.

Creating Focal Points

The last step is to control the path of the viewers' eyes as they explore the painting. The viewers will visually take a walk in the painting, just like they would in a real wooded stream. The artist controls the visual path of the viewer though visual points of interest called focal points. When you are refining the last stages in your painting you still have to ask your two intellects the Five Important Questions.

The Fifth and Final Important Question

One of the ways I start the end process to my painting is by asking the fifth and final question, "What do I see first, second, third, fourth, fifth, and sixth?"

I want the viewer's eyes to travel to at least six parts of the painting before he or she goes to the next painting on the wall. If the painting is really powerful, the viewer's eyes will actually travel six revolutions around the entire painting. I stand 30 feet (9.1 m) away from my painting and start walking toward it to see if something new is revealed. I want to have something new come into focus for every 5 feet (1.5 m) that I travel. If you visit a gallery, you will find that only two paintings out of twenty will funnel the audience to them. It doesn't matter who the audience members are—adults, children, or the museum staff. Powerful artists make the viewers dance!

I use all the visual tricks I can to control the viewer in that visual walk to and through my painting. I learned the tricks by accident, usually by talking to the viewers about what they see and why. Remember that art is a human mirror—it reflects the artist, viewer, and history all at the same time. If the art is powerful enough, each of the three reflections will reveal new directions for all.

Once you find something in your painting that gives you direction, ask yourself, "Why or how does this element provide direction?" Your answers will usually start out with the word "contrast." That element will stand out from the surrounding area in combinations of focus, value, hue, brilliance, or shape.

The next question to ask is, "How do I enhance or dull that contrast?" To bring the object closer, push the value, brilliance, sharpness, and size to a higher level; to

The red "trim" color pushes the viewer's eyes around the painting.

move it back into the picture plane, do the opposite. You can enhance or dull the contrast by either changing the object or changing its background.

Colors and shapes that are similar attract each other. We are programmed to look for visual patterns. This is how we were hardwired to look for food or danger. The eye naturally tries to find matching shapes and colors around the canvas; in the process, a sense of travel and distance is created in the viewer's mind. Many of nature's

↑ Adding color, value, contrast, and overlapping shapes

color schemes are the same color schemes used by designers: usually, a large area of two similar colors plus a smaller area of trim color, often complementary to the first color. Much of advertising and commercial design is also based on this simple, three-color relationship. The trim color triggers an emotional curiosity in our subconscious mind. All colors and values have an emotional component that is quite universal.

I use a "trim" color to push the viewer's eyes around the canvas. The yellow and blue-green foliage in the example painting is a perfect background for a complementary trim color such as quinacridone red. Your eyes look for like colors and follow them. Complementary colors stand out, so this color is seen quickly. The right bottom foreground foliage was highlighted with yellow and red, and some of the

shadows were deepened to create more contrast and overlap the sides and tops of the bushes. The contrast and defined overlapping shapes pushed more depth into the painting. A few flecks of phthalo blue were added next to the red to create a shimmering effect.

The front of the gravel bar was lightened with white to pull it forward. (Remember that light values come forward.) I also added small white ripples in the water to accent its movement. Some of the trees, especially on the far right, received yellow, red, and orange highlights to push your eyes up into the sky and keep them from moving off the page. You can use many different combinations to orchestrate eye movement. Keep experimenting and asking, "What do I see first, second, third, fourth, fifth, and sixth?" Then ask, "Why?" You will get answers!

⬆ Creating red and yellow trim color focal points

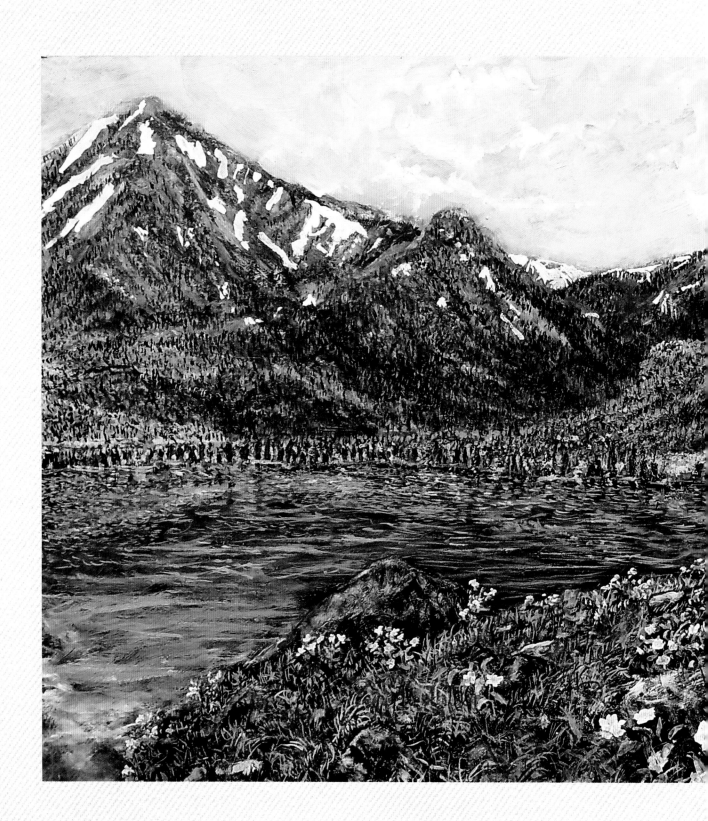

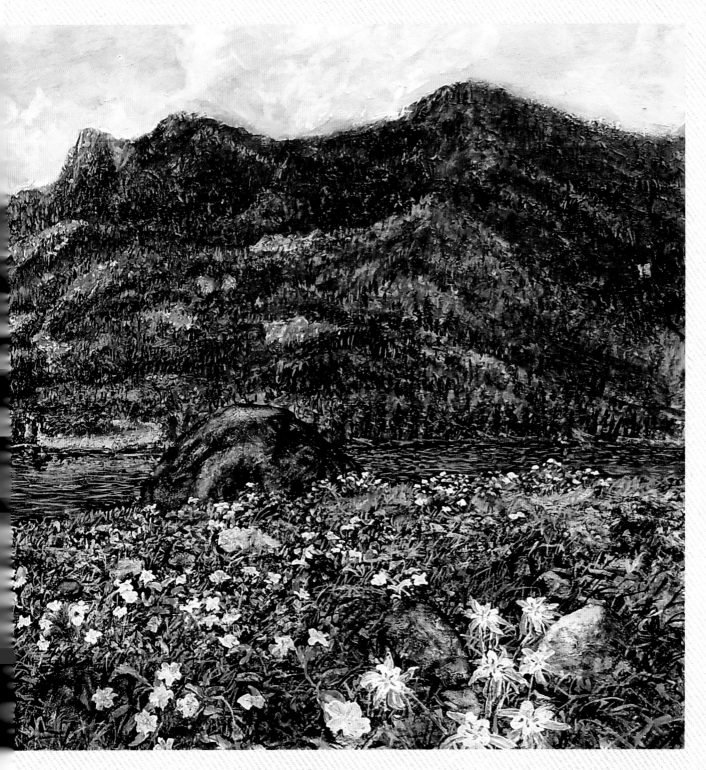

⬆ *Big Creek Lakes, Colorado*; acrylic on canvas, 24" x 48" (61 x 122 cm)

5

PAINTING TECHNIQUES

In chapter 2, we learned about the five basic fractal shapes: oval, blade, shield, amoeba, and composite. Your job as a painter is to match your brushstrokes to the large and small fractal shapes (or visual rhythm) of the object you want to paint. In this chapter, I will take you through a few of the techniques used to create my paintings, many of which we learned in the previous chapters.

We used a random chaos underpainting to create the detail and elements in the example painting (see page 61), hoping that all the accidental combinations will work. Chaos would work. But we discovered that we needed to adjust that chaos further in some parts of the painting. In this chapter, we'll explore various ways of creating an adjusted chaos that fits the visual subject matter in a more efficient way. To create an adjusted chaos, we first determine the basic visual fractal rhythms of the subject matter (from the five fractal types) and then apply those fractal combinations to the canvas. Creating an adjusted chaos allows you to paint faster and more efficiently and gives you more control.

Although some of the adjusted chaos underpaintings are created with different tools and techniques, the basic painting philosophies and processes are the same.

➷ *Cannon Beach*; acrylic on canvas, 24" x 32" (61 x 81.3 cm)

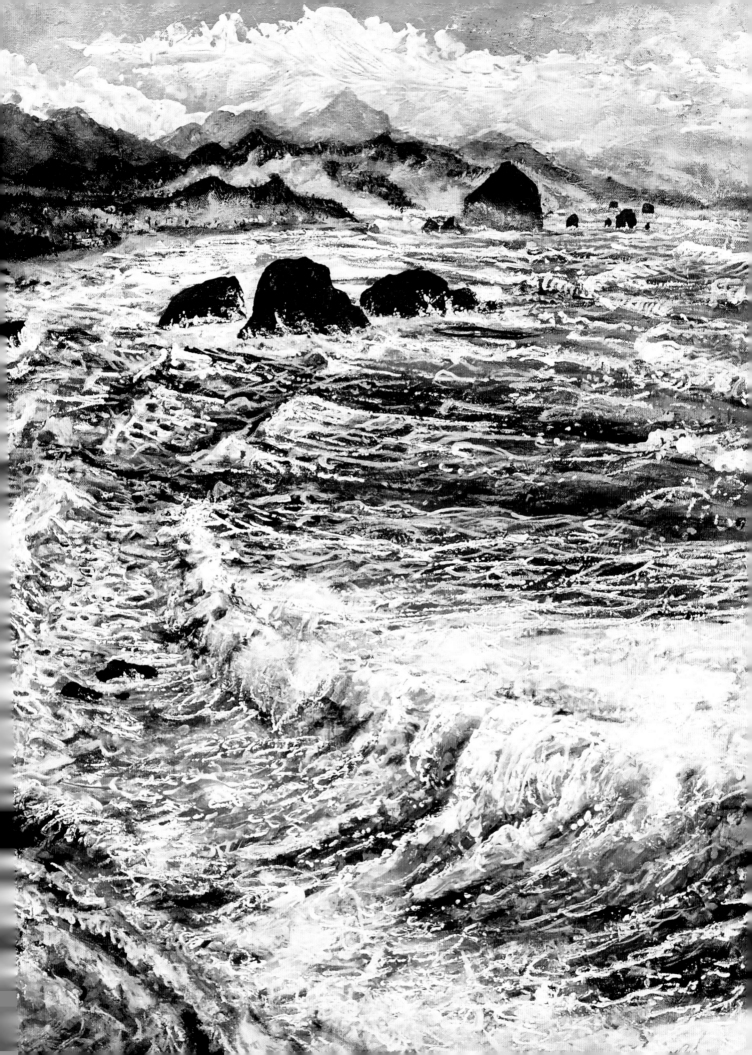

PAINTING TECHNIQUES FOR MOVING WATER

For this technique example I'm using an ocean scene overlooking Cannon Beach, Oregon. Rather than starting with a random chaos, we will create an adjusted chaos. The entire painting, except the sky, is created by long and thin fractal brushstrokes. These thin, bladelike fractals permeate everything. Their blade shape fractal rhythm is so strong that it would be difficult not to capture the waves using them.

It is important to understand that the adjusted chaos is created by any means necessary. Try to visualize the major types of fractal shapes that create the underlying structure of the objects in the painting. Then experiment with your brush or any tool that can duplicate those visual rhythm fractals. For this painting, we will use a brush and a plastic cake-decorating tip to create the adjusted chaos.

Remember, there are only five basic fractal shapes to worry about. This means that you can adjust the type of fractal to fit specific sections of the painting before you even start the overlays of glazes.

⬆ **Blur your vision to see the fractals.**

tip

Remember that the chaos, whether random or adjusted, is a specific painting tool used for highly textured and complex images. The chaos tool, like all tools, will not work for every painting, nor for all parts of the painting—especially if that part has very little texture.

Painting the Large and Small Fractals

To start, blur your vision and quickly paint the larger fractals with a ½" (1.3 cm) flat sable brush, using combinations of ultramarine and cobalt blue. Add a little acrylic gloss medium to your mixture to make the paint flow evenly. Like Claude Monet, paint the major movements of the painting in the first fifteen minutes. Movements are the visual elements in a painting that catch your eye's attention. The major movements are usually what you see first with your vision blurred.

Switch to smaller flat brushes to create smaller and smaller curvilinear blade fractals that zigzag across the canvas. Keep in mind that you have to make the fractals smaller and thinner so they appear to recede into the background. The fractal brushstrokes are curvilinear and when bundled together, they create oval fractal shapes.

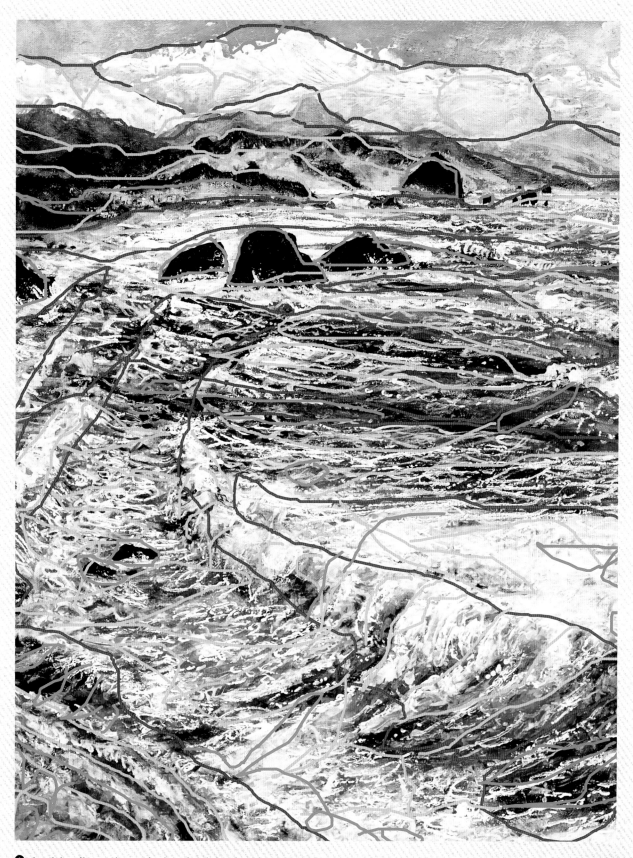

⬆ **Applying the major and minor fractals**

⬆ **Blade fractals recede into the background.**

It is also important to notice in what direction the blade fractals flow inside the large, major fractals. Sometimes they are parallel with the perimeters of the large fractals, creating waves that stack on top of each other and recede into the distance. In other places the smaller fractals are bundled perpendicular to the major fractal perimeters, like contour lines on a map, creating troughs in the waves.

I found an old plastic cake-decorating tip used for applying frosting. I often use a "birthday cake" metaphor when teaching, so I thought it would be fun to paint with a cake-making tool. The icing tip fit my 6.75-ounce (200 ml) tube of acrylic titanium white perfectly. With a little practice, I was able to duplicate the white and dark blue, fine, long, dotted blade fractals and the small oval ripples in a tenth of the time it would have taken using a liner brush.

⬆ Stacked blade fractals

tip

Moving water, whether it is in ocean surf, a river, or a waterfall, has similarities to torn tissue paper. Pull off 6' (1.8 m) of toilet paper and loop it so you have a folded piece about 2' (61 cm) long. Tear uneven holes through all the layers until the folded sheet is 50 percent holes. Hold the paper by one end: notice how it drapes and how the holes turn into long flowing ovals. The sheets of water drape and tear into ovals as they move.

→ **Torn tissue looks like water in motion.**

↑ **Using the cake-decorating tip to paint the ripples**

→ **Detail of ovals in the waves**

⬆ **Dry-brushing over the curled fingers like brushstrokes of the surf**

Painting the Large and Small Ovals

Once the large and small blade fractals are laid down, put in the large and small, light and dark ovals that follow the lines of the thin fractals, like pearls on a string. When you look closely, you will see that some of the ovals are white rings with dark centers.

Remember, if you find yourself repeating any fractal shape over and over, you are not painting but writing! In nature, each fractal shape in an area might be similar in shape but never the exact same size, length, or shape; neither are they spaced evenly. Keep asking yourself the first question, "What am I doing over and over too much?"

Dry-brushing

The next major step is to dry-brush the areas of the painting where the waves turn into surf. Put a small amount of white paint on a ¼" or ½" (6 mm or 1.3 cm) round or flat hog-hair brush and rub the brush on a piece of paper until the brushstrokes look like soft chalk. Dry-brushing softens the contrasting areas and creates a soft texture overlay that hides much of the sharp,

tip

Always get up from your chair and stand 10 to 15 feet (3 to 4.6 m) away from your painting. Hold your photograph out at arm's length and look at the painting and photograph at the same time. This helps you see how the painting is progressing and figure out where the shadow glazes go.

angular brushstroke edges underneath. Dry-brushing also gives the underpainting a more even value by taking away the strong value contrast.

Apply heavier applications of white in the centers of the surf where it starts to curl. Imagine the surf is like your slightly cupped hand, fingers curled and ready to grab something. You will see curled white fingerlike shapes dangling from the edge of the soft cloudlike white shapes you made with the dry brush. A small size 000, round sable liner brush works well for this. Add a little water and medium to the paint to make it flow. The cake-decorating tip can also be used.

Adding Glazes

Now, go over the pure white fractals, white dry-brushing, and other colors to create the cool blue and green shadows on the bottoms and sides of the waves. Experiment with transparent glazes of varying strengths, beginning with one part paint to six parts acrylic medium. Remember to paint all the highlights in pure white and then go back and paint over them with colored glazes: the highlight colors are so subtle and similar in value, hue, and brilliance that it would be difficult to mix each highlight color separately. It is much quicker to paint an overlaying glaze and adjust its value and color saturation by using a wet cloth or cotton swab to wipe off the excess paint from the highlight. Remember, transparent glazes are colors mixed with gloss acrylic medium applied over dry paint.

PAINTING TECHNIQUES FOR GRASS

Painting grass can seem a little overwhelming because of the sheer number of blades that need to be captured. This painting is one of my favorites. It is a view from the porch of a little farmhouse overlooking the beautiful rolling hills and grasslands loaded with colorful May wildflowers near Weston, Missouri. The painting documents the day of my wedding to my beautiful bride, Annie, and the combining of my two and Annie's five children.

For this technique example, we'll use only the grass portion of the painting and will begin the process by creating an adjusted chaos.

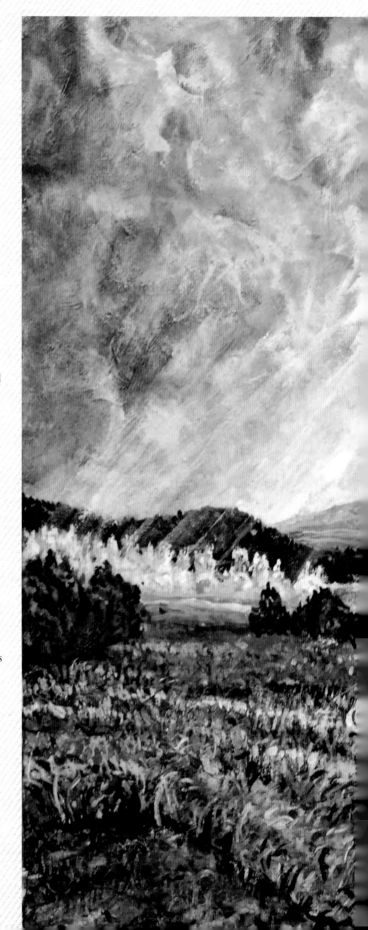

Wedding Day; acrylic on canvas, 24" x 32" (61 x 81.3 cm)

→ Seeing the fractals with blurred vision

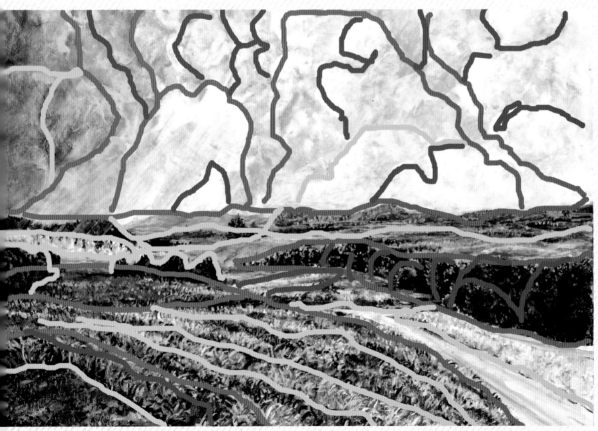

↳ Applying the major and minor fractals

Painting the Large and Small Fractals

Grass is painted in a similar method to the one you used for the ocean painting. The major fractals are long, thin, blade fractals that become smaller and thinner so that they appear to recede into the background. The secondary blade fractals, or individual grass blades, are curled, like fingers or ocean waves.

The approach to this painting is the same as that for the previous painting: blurring your vision and painting the major fractals as fast as you can. But before you do this, create an adjusted chaos by laying down a base of small, grasslike curved blade-fractal strokes of transparent color in the large triangle area containing the perimeter of the field. Use a size 1 round sable brush and make as many curvilinear, thin blade-fractal grass strokes of every color on your palette. Add enough gloss acrylic medium to the paint to ensure that each color is transparent enough to let the white of the canvas show through.
.

↻ Creating the blade-fractal brushstrokes

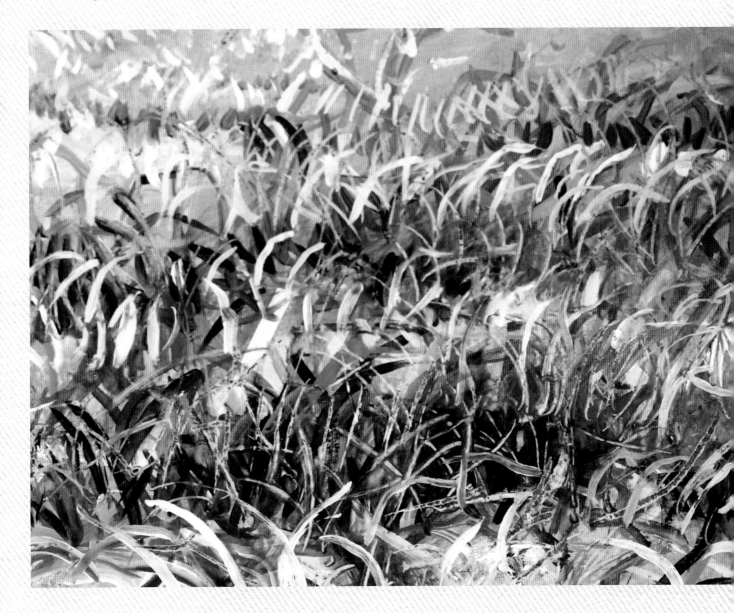

Applying the Grass Blades

When the adjusted chaos in the perimeter of the field is filled with blade fractals, apply individual brushstrokes of grass. Painting grass is usually overwhelming for beginners because they falsely perceive that all of those millions of blades of grass have to be individually painted. But because the adjusted chaos has already created most of the blades, you don't have to paint many at all.

↻ Adding the shadow glazes

↺ Adding the tops and bottoms of the grass blades

Adding the Shadow Glazes

Add the major and minor fractals over the adjusted grass chaos with transparent paint. Remember to blur your vision to see the major and minor shadow fractals in the grass section. The shadow fractals were painted with transparent ultramarine, Payne's gray, and dioxazine purple glazes.

Use any tool with a sharp point—a kitchen knife, palette knife, sharp nail, or the end of a brush—and scrape through the dark, wet, shadow glaze to reveal bright grass blades from the underlying chaos. This technique allows you to scratch very thin blades fast. Overlap the scraped grass blades by giving each one a curved "S" shape. If you find yourself scratching lines that are equal in spacing and size, stop and ask yourself the first question again.

After scratching through the glaze layers, add a few light and dark opaque grass blades in contrasting background areas to highlight the tops and bottoms of the grass "waves." These are similar to the curved, white fingerlike structures used to make the tops of breaking ocean waves in the previous painting technique example on page 99.

⬆ *Morning Light Flint Hills*; acrylic on canvas. 15" x 30" (38.1 x 76.2 cm)

⬆ *Wedding Day*; acrylic on canvas, 24" x 32" (61 x 81.3 cm)

PAINTING TECHNIQUES FOR CLOUDS

One of the most important points to remember when painting clouds is that much of the sky and clouds during a bright or even an overcast day are equal in value. The skyscape components are usually distinguishable not so much by value or brilliance but by their hue changes. This is why unfiltered black-and-white photographs do not document the sky well.

Colors of equal value and brilliance seem to glow. You can push that glow by placing complementary colors of the same value next to each other. (Be careful not to mix or overlay transparent complementary colors—remember, complementary colors turn brown when mixed.) Sunsets and sunrises are good examples of extreme glow. Sunsets are made up of complementary colors that are close to each other in value and brilliance. They're hard to paint because it's difficult to keep the colors from bleeding into each other. You need to be patient and let each color dry separately before adding a complement next to it.

The clouds technique example uses the sky in the *Wedding Day* painting. It is a sky in transition after a storm with elements of several different types of weather.

Painting the Major Movements

Although part of this painting is highly textural—the grass and trees—the sky is not textured, which means we do not need to create a chaos underpainting for it. If a strong chaos is needed for most, but not all, of the canvas, you can paint the unneeded section of chaos white or leave the chaos out of that area. For this technique example, we will not use a random or adjusted underlying chaos for the sky. Although some highly textured skies can be made with a strong underlying chaos, this type of sky will be made without one.

Before you start your sky, make sure that area is white. Paint the white canvas area with several layers of gloss acrylic medium. This makes the canvas smooth, so the glazes flow evenly and the canvas texture doesn't overpower the softness of the glaze. If you are working from a photograph, blur your vision and quickly put down the major color shape movements with transparent paint glazes. For this, use cerulean blue, phthalo blue, ultramarine blue, dioxazine purple, cadmium yellow light, Payne's gray, and titanium white. Start with the blues alone and use the transparent gray and opaque white last to bring out the edges of the clouds.

Dry-brushing and Refining

Apply another coat of clear acrylic gloss medium over the glazes and let it dry. With a 1" (2.5 cm) hog-hair flat or round brush, dry-brush the canvas with an uneven light coat of chalklike white paint, using circular brushstrokes. The white dry-brushing gives the glaze colors a more equal value. After drying, coat the canvas with another light coat of gloss medium. When the medium is dry, put down the minor color movements in the sky with transparent glazes and repeat the coat of gloss medium and white dry-brushing.

1 Refining minor movements
2 Refining minor movements
3 Refining minor movements
4 Refining minor movements

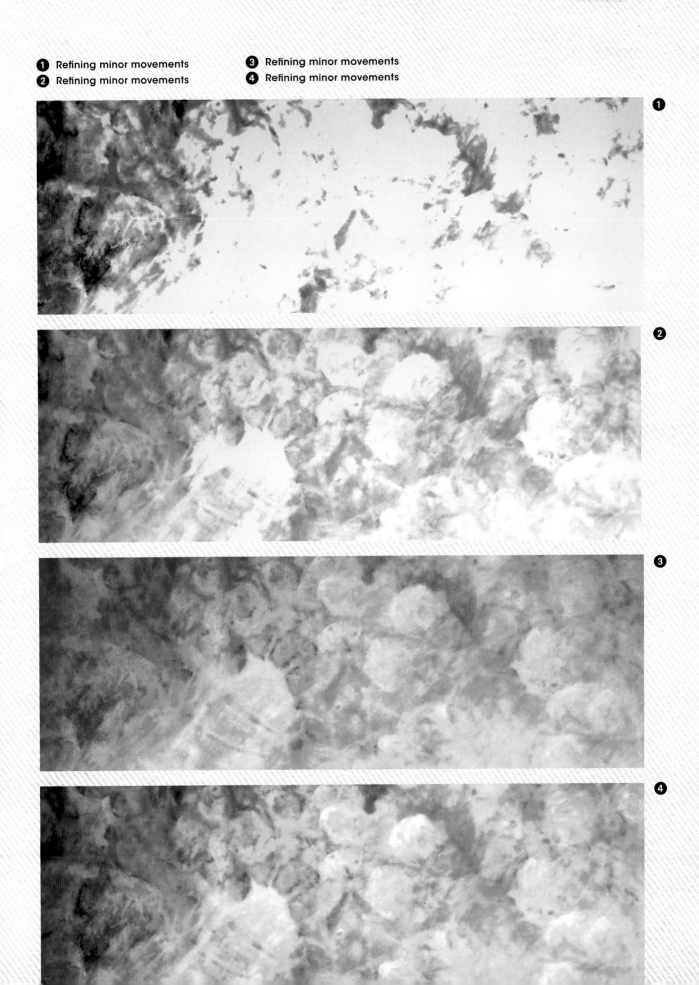

1

2

3

4

Continue to refine the painting in this way until it starts to become what you want. Stay transparent with the color glazes and white dry-brushing. Be particularly aware of the interaction of cool and warm whites in the clouds and their sharp and soft edges. You will also notice that clouds, like fractals, have the five basic shapes. In the end, you will have a sky that glows with light and power.

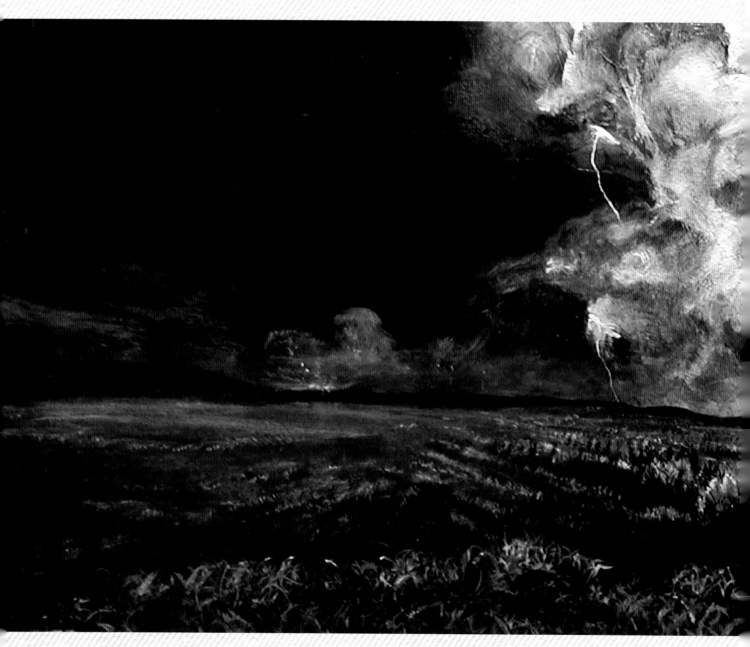

⬆ Many layers of glazes were used to create these storm clouds.

tip

Acrylic dries fast, but you still need
to be patient; this process is worth
it. Most complex skies have fifteen
layers before they are finished!

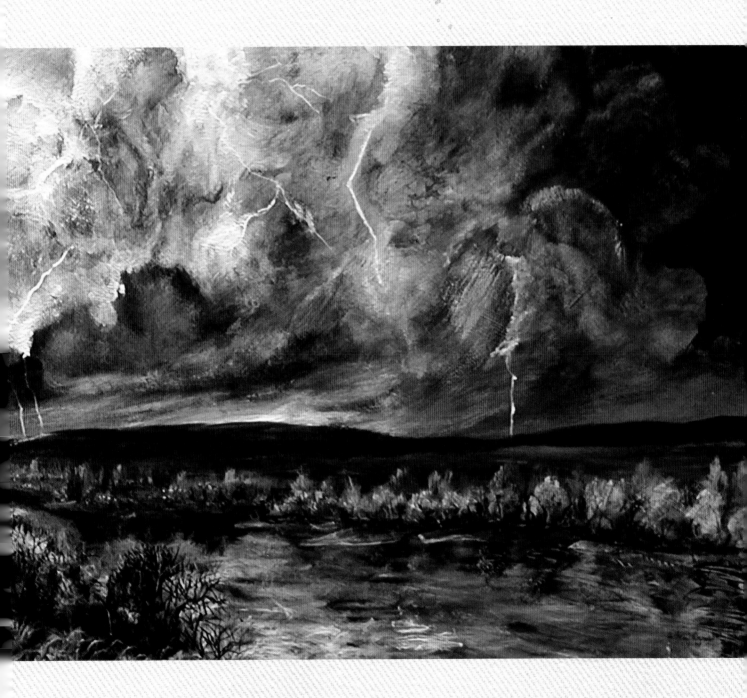

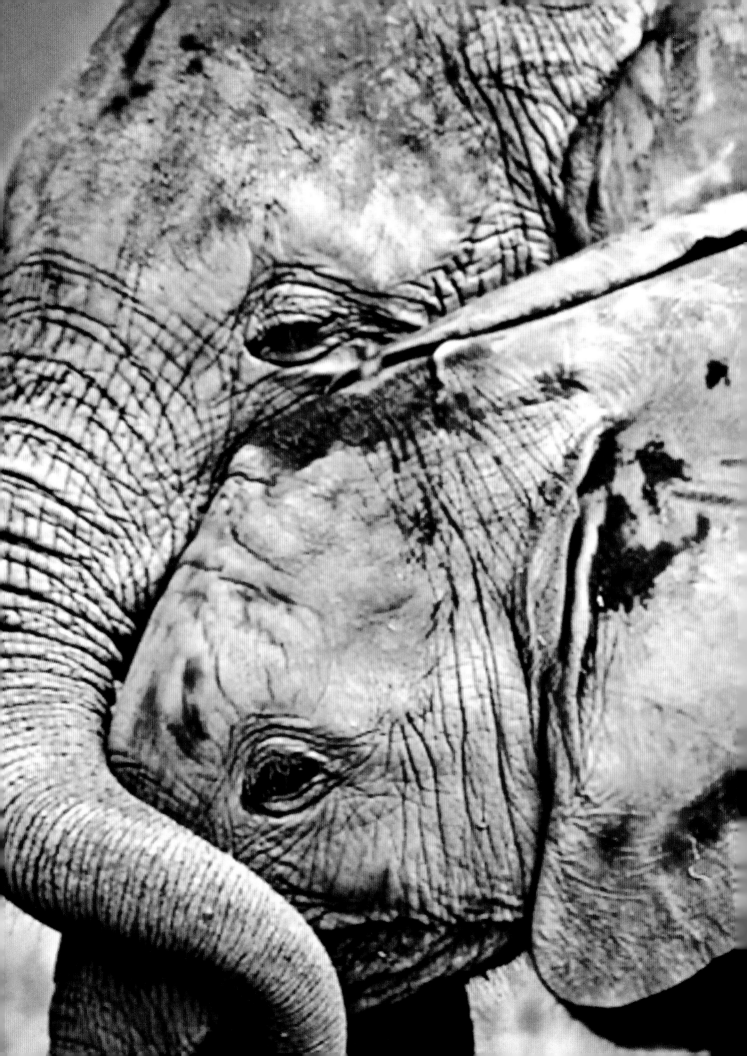

PAINTING THE ELEPHANTS

The chaos technique can be used for more than landscapes. Any subject with a lot of texture will work. The elephants in this photo read almost like old, weathered rock. Their wrinkles and mud-caked skin have a landscapelike look.

Creating the Adjusted Chaos

Cover the white, gesso canvas with a heavy coat of acrylic gloss medium to hide the rough, canvas-weave texture. We will be using newspaper to stamp an adjusted chaos in a slightly different way than we did previously. Instead of putting the paint onto the canvas and stamping into it, we'll be brushing paint onto the crumpled paper and then applying it to the canvas. Use raw umber, burnt sienna, cadmium orange, cadmium yellow light, alizarin crimson, ivory black, and titanium white to create the adjusted chaos for the elephant underpainting.

Don't apply all the colors on the crumpled newspaper at once. Experiment and play with the mixtures. Use different stamping pressures and positions. Keep the newspaper crumpled and let the triangles print the wrinkles. When the crumpled newspaper becomes too saturated with paint and starts to flatten out, use a new piece.

Study the photograph (a color photocopy will make it easier to work with) and try to manipulate some of the stamped marks to look like the textures and color of the elephants' skin. Apply more white and yellow to the mixture on the newspaper for the lighter parts of the skin and more black and brown colors for the dark muddy areas. Drag the newspaper along the canvas surface to create curvilinear marks on the canvas. Don't get carried away and scrub the canvas until it becomes one solid color. Be sure to keep a lot of white showing.

Squint your eyes to look at the photograph and at the canvas to see how you are doing. Take no more than ten minutes for this step, so you don't overwork the chaos. Remember that the adjusted chaos is the framework *under* the detail, not the detail itself. When the chaos is dry, give the canvas a heavy coat of acrylic gloss medium.

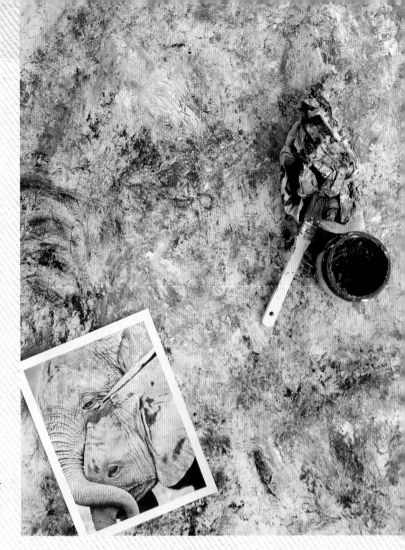

⬆ The adjusted chaos for the elephants was created using a paint-covered newspaper "stamp."

tip

Make sure your canvas size has the same ratio as the photo. Use the elephants' eyes as an increment of measurement, and be careful to put the eyes in the right place on the canvas.

Creating the Elephant Silhouette

To create a silhouette of the elephants, we need to paint in the background; the parts of the painting that are *not* the elephants (the green area in the painting, right). To do this, first paint over the chaos that forms the background area with solid white. When the white paint is dry, apply glazes of permanent green, cadmium yellow, and titanium white over the white. The green background is out of focus, so you want to apply soft, abstract cloud-like structures.

Start preparing the chaos, which is now only inside the elephants' perimeter, for the detail. Add a little titanium white to a size-2, flat hog-hair brush and dry-brush white into the areas of the chaos that need to be lighter. Take your eyes out of focus when you look at the photograph to see those light areas. Keep the dry-brushing very transparent.

⬆ Adding the background to create the elephant silhouette

Mix the colors to fit the general colors of the elephants' skin, and dry-brush those colors on. Don't try to create the shadows; create only what is *underneath* the shadows. You can apply a few dark wrinkles, just to help you separate the legs, ears, and trunk. When the paint is dry, coat the canvas with another heavy coat of acrylic gloss medium.

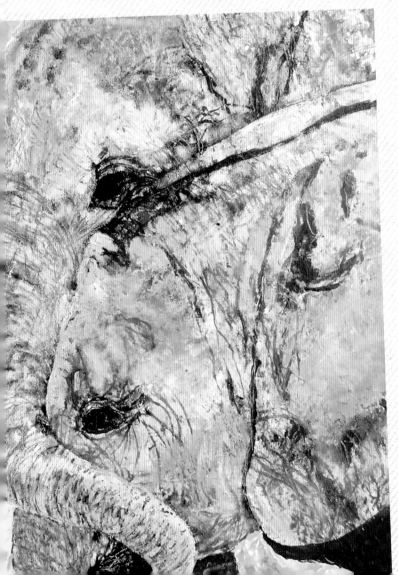

⬇ Elephants' basic visual skin color including highlights

⊃ Create a wrinkle blueprint by making a black-and-white copy of the photo.

Painting the Wrinkles

The elephants have many confusing dark wrinkles. The wrinkly skin actually shapes these two animals. Each wrinkle is not a line but a long, curvilinear blade fractal. Use burnt sienna, raw umber, and black to paint the dark part of the wrinkles. Add 25 percent acrylic gloss medium to the colors so they flow and stay transparent. Dip your brush in water to keep it wet and pointed, and keep the paint thinned down enough so the color mixture can brush a long wrinkle. Use size 000 and size 0 round, sable liner or rigging brushes to paint the wrinkles.

All wrinkles have a light highlight and a shadow side. To see this effect, study the clothes you are wearing: notice that the highlight side of the wrinkles faces the incoming light source and that the shadow falls on the opposite side. The light source for the elephants is coming from the upper left corner of the picture.

There are five values in a wrinkle—but don't let that intimidate you; just start blocking in the dark shadow side first. The wrinkles are not thickness lines but long blade fractals. They form around the body shape, similar to contour lines on a map, and define the shape of the object underneath. If you keep the paint transparent and

apply it in an uneven manner, many of the values will be accidentally created. Hold your brush between the thumb and forefinger so you can roll the brush as you apply the paint stroke. This slightly out-of-control action will make copying the long blade fractals easier than if you used the traditional handwriting position.

Copy as closely as possible the main wrinkles that you see with your eyes slightly out of focus. You do not have to copy the secondary and smaller wrinkles exactly. As long as you pay attention to the direction the secondary and smaller wrinkles take when they curve over the form, you should be successful. Always try to retain the correct spacing between each wrinkle.

tip

It's a good idea to place a mark on the photo indicating the position of the main light source. Use small, yellow adhesive dots, which easily peel off the photos. The dots can be found at any office supply store.

⬆ Adding the elephants' wrinkles

Carve the end of your brush to a point and scratch through the wet paint of a freshly painted wrinkle. You may find this a good technique for adding a second and third value or even a smaller wrinkle.

➔ **Major wrinkles**

Adding the Highlights to the Elephants' Wrinkles

To add the highlights, use titanium white and apply the paint in the same consistency and way that the dark sides of the wrinkles were applied. The white paint will be somewhat transparent and will let the background color bleed through. Don't be too concerned about the extreme contrast between the adjacent dark and white fractal wrinkles. The color value of the highlights will be adjusted with overlaying glazes later in the painting. Just focus on which side of the shadow wrinkle you apply the highlight. Keep checking your photograph and the mark indicating the light source.

The trunk of the larger elephant, which is in the light, is interesting because the highlights create an uneven, curvilinear checkerboard pattern that becomes smaller as the wrinkles descend the trunk. Halfway down the trunk, the white highlights become small oval dots that string together and make the curved fractals around the trunk.

↙ **Major and minor shadow and highlight wrinkles**

The smaller elephant's trunk is in shadow; its diamond pattern is applied with the same highlight techniques used for the larger trunk but without the oval-dot highlights. Later, you will use a dark glaze to shade it.

When the paint is dry, apply a light coat of acrylic gloss medium over the entire painting.

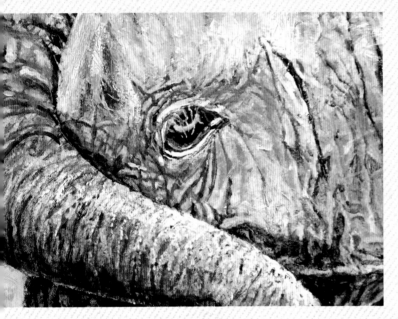

⬆ Small white oval fractals on trunk

⬇ Adjusting the elephants' color with glazes

Adjusting the Color and Creating Shadows

Stand far enough away from the painting to see the photograph and painting at the same time. Use this perspective to locate all of the major highlights. As you paint, moving back to check your progress. Paint the major broad highlights across the ears and foreheads of the two animals using white mixed with gloss acrylic. Use the same mixture you used for the wrinkle highlights.

Once you have adjusted the large broad highlights, begin to adjust the total color of the two elephants. Use a mixture of 75 percent acrylic gloss medium to each color that you use. You can adjust the mixture to fit the color saturation, but remember that it is best to add layers of glaze, rather than adding all the color at once. Use the end of your brush to scratch smaller wrinkles and blood veins into the wet glazes and highlights.

The final step is to add the shadows, such as those in the smaller trunk. Use a dark glaze, and be sure to leave some detail showing through. The shadows are a mixture of Payne's gray and acrylic gloss medium. Keep this mixture very transparent, starting with a 50 percent mixture for the shadow glaze. You can always adjust the value by adding another layer over the dry shadow glaze. As always, take your time and keep stepping back from the painting to check your progress against the photograph.

➔ Finished elephant painting

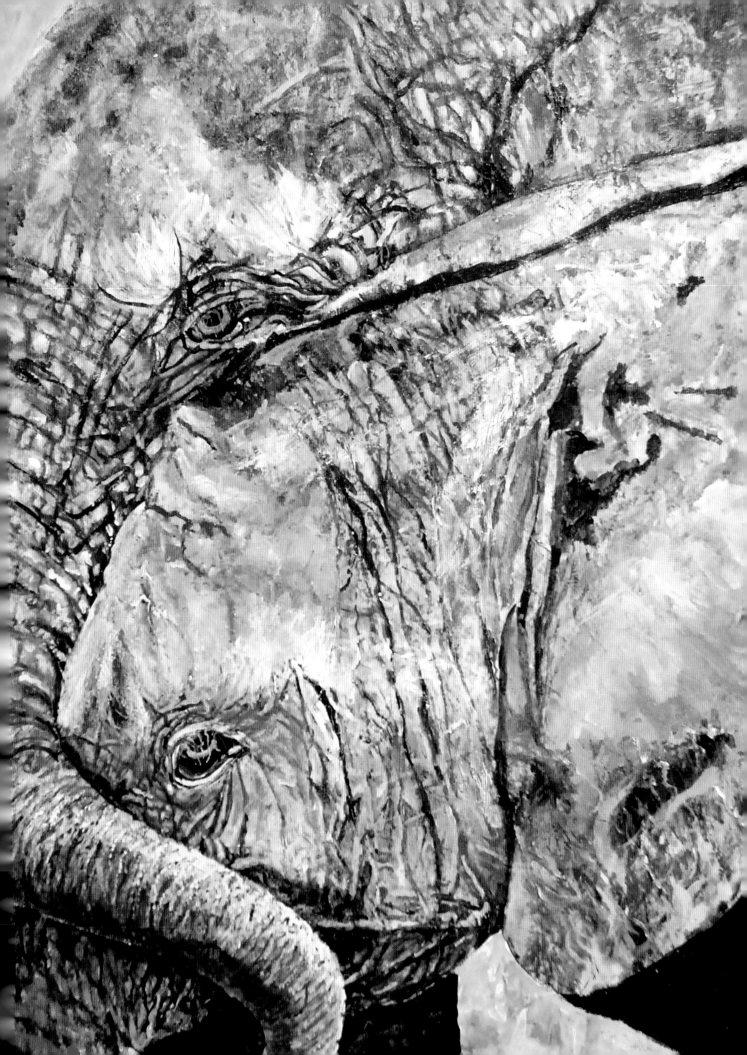

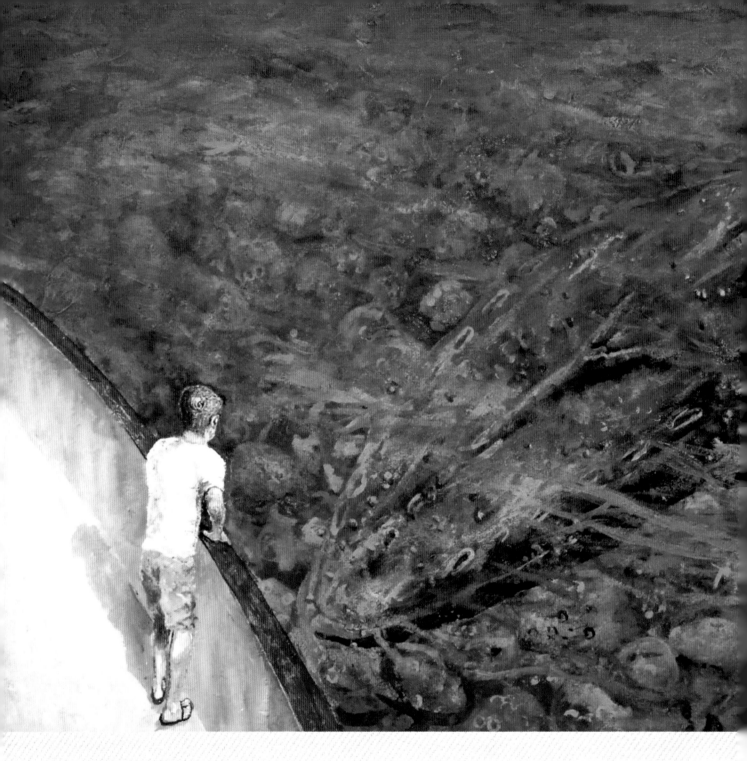

DANE'S WHALE

About eight years ago, my family and I vacationed on the island of Maui. We went on a whale watch sponsored by a whale research organization and had an amazing time watching a mother humpback whale and her young calf, which was the size of a pickup truck, breach (jump out of the water). A very rare and exciting thing happened during the expedition—the mother whale swam underneath our boat. My youngest son, now in his early twenties, found the experience so powerful that he wanted a painting of the whale. Unfortunately, our camera was not working at the time, so I gathered as many research photos of humpback whales as I could as references for the painting. I also used quite a few photos of the ocean in that area that I taken for future paintings. The whale painting is a composite of those photos and my memories.

↑ Finished painting of *Dane's Whale*

Creating Adjusted Chaos with Aluminum Foil

We are starting again with an adjusted chaos that closely fits the water. The water was so clear you could see the sea floor 100 feet (30.5 m) below. The rocks on the bottom were large and round, some the size of houses. The humpback whale, which was covered with barnacles and magically camouflaged against the seafloor, was a transparent apparition, slowly appearing, dwarfing our boat, and then disappearing into the green, giant-marble-game seascape.

To create the chaos, the canvas is first covered with dots of paint, using the same technique described in our first painting example on page 60. Use cadmium yellow, cadmium orange, brilliant green, phthalo green, cerulean blue, phthalo blue, ultramarine blue, dioxazine purple, and titanium white to create the chaos.

While the paint is still wet, use a crumpled piece of heavy aluminum foil to stamp into the paint. Use a very light touch, so you don't flatten out the crumpled foil. Foil is used because it creates more contrast and leaves a lot of white on the canvas. You need a lot of white, because the sea bottom was bright green and the extra white creates brighter colors. Work quickly so the paint doesn't dry.

Lay tissue paper onto the wet canvas and lightly pat it down. Be careful not to drag it; you don't want it to smear. Wait two minutes, to let the paper soak up the extra water and paint, and then slowly peel the paper off the painting. This technique creates more transparent colors. Later, we will reshape the triangle fractals into round rocks. When the chaos is dry, apply a heavy coat of acrylic gloss medium.

tip

You can use the aluminum foil-and-tissue-paper blotting technique for triangle-shaped, rocky streams as well.

⬆ Adjusted chaos with wet paint dots

⊕ Adjusted chaos after stamping with aluminum foil

⊕ Using tissue paper to blot excess moisture from the wet paint

⊕ Result of blotting with tissue paper

Stamping the Rocks with a Sea-Sponge Stamp

The volcanic rocks on the sea bottom had many holes that resembled huge spherical sponges. To create these holes, stamp them out with a natural sponge called a "wool" sponge; these will later become part of the rocks. (Note: It's easier to create the holes first, and then paint the perimeter shapes of the rocks later.) You can find natural sponges at hardware and paint supply stores.

Dip the sponge lightly in the paint and apply it with a very light touch. Use cadmium yellow, brilliant green, dioxazine purple, and titanium white paint for the rocks. Wash and blot the sponge dry before changing colors. Make the rocks incrementally smaller so they recede into the background toward the top of the painting. You'll need to adjust the sponge stamp to fit the change in size.

G Detail of sea-sponge stamping

⬆ Result of sea-sponge stamping

Turning the Chaos into Round Rocks

Look for round rocks in the chaos. Remember to find the rocks in the chaos and not in your imagination. The rocks that *appear* in the chaos will be more complex than those you try to create yourself. Try to make them smaller and thinner so they recede into the background. A ¼" (6 mm) round, Japanese, bamboo-handle watercolor brush works well to outline the rocks. These inexpensive brushes are used for calligraphy. I love to use them because they hold a lot of paint and can create both wide and thin lines. Use dioxazine purple mixed with acrylic gloss medium and water to make an inklike consistency. Keep the outline very transparent, smudging the outside edge of the line with your finger to create a shadow. The inside edge of the outline will create the rock.

➜ Outline the perimeters of the rocks in the adjusted chaos.

Creating the Water's Surface

As the surface of the sea recedes into the background, the water reflects the light more and becomes less transparent. To create the illusion of a flat surface receding into the background, you need to create light and dark wedge shapes that bisect the water's surface. If this is not done, the surface of the sea will flip up and look like a wall instead of a flat, receding plane. Use glazes of phthalo, cerulean, and ultramarine blue to make wedges and zigzag waves that recede into the distance. Use glazes of phthalo, permanent green, and brilliant green to give the rocks their bright color.

↩ Create basic light and dark wedge shapes to bisect the water's surface.

Painting Techniques 125

Painting the Whale

One of the powerful parts of the whale-watching experience was how ghostlike the whale looked as it glided silently under our small boat. Paint the whale's silhouette with dioxazine purple and ivory black mixed with 25 percent gloss medium. This mixture creates the illusion that the whale is transparent. Continue to apply more glazes to the water and ripples, and add more detail to the whale. Use transparent paint glazes to make the transparent waves and ripples that cross the whale. The layers of transparent ripples and waves give the whale the appearance of going in and out of focus in the water. Be patient! You'll need to apply many layers of glazes to create this illusion. I stopped counting after twelve.

Painting the Whale Watcher

The composition of this painting is based on an interior tangent problem (see page 85 for more on tangents). The whale almost touches the boat's side and the figure of the whale watcher. All tangents create powerful visual tension; in this painting, the tangent design element translates into emotional tension between fear and awe.

I did this by having the viewer's eye move along the whale's body and the intersection of the side of the boat but avoided having the eye stop and become trapped, because the whale's head almost disappears and does not quite touch the boat. By not completing the intersection, or tangent, of the whale and the side of the boat, I created a way out for the viewer's eye. Making the whale's head almost disappear allows the viewer's eye to follow a path back toward the tail and then pick up the yellow-green rocks spiraling back to the whale's flipper.

◐ **Transparent whale silhouette**

⬆ Finished painted detail of the whale watcher

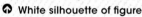
↑ White silhouette of figure

↑ Basic local color of figure

After painting the deck and railing of the boat, paint the white silhouette of the whale watcher. When painting figures, it is easier to paint the background first.

Once the figure is painted white, block in the basic local colors of skin and clothes with a size 00, round sable detail brush. If you are painting a figure from memory, try to find or create a photo that shows the figure in the correct position. Blur your vision to determine the major and minor fractals in the figure, and then paint them

with glazes. Cover the dark brown hair with a layer of light brown, and while the light-brown paint is still wet, scratch through the paint with the end of a brush to create the dark brown shadows in the hair and to define individual hairs.

The final highlights are painted with opaque white; the shadows are painted with a transparent glaze. The sandals are painted at the very last using a size 000, round sable detail brush.

⬆ Adding basic shadows and detail to figure

6

GALLERY

These landscape paintings are examples of underlying painted chaos, texture stamping, and multiple overlays of glaze. Each painting uses the same basic painting techniques outlined in this book. It is your birthright to be able to document through paint your personal dance with nature. It is my sincere hope that you let the artist in your soul out into this world. We all need to share in that joy.

(All paintings by Dan Carrel; clockwise from top left) ↗

Taro Fields; acrylic on canvas, 20" x 24" (50.8 x 61 cm)

Aspen Gold; acrylic on canvas, 24" x 32" (61 x 81.3 cm)

April Rain; acrylic on canvas, 36" x 71" (91.4 x 180.5 cm)

Maui Falls/ Cave; acrylic on canvas, 20" x 24 (50.8 x 61 cm)

Kauai Cliffs; acrylic on canvas, 20" x 24" (50.8 x 61 cm)

(All paintings by Dan Carrel; clockwise from top left) ↻

Big Creek Lakes Ghost; acrylic on canvas, 20" x 24" (50.8 x 61 cm)

Austin, Texas, Fall; acrylic on canvas, 20" x 24" (50.8 x 61 cm)

Kauai Home; acrylic on canvas, 20" x 24" (50.8 x 61 cm)

Maui Falls/Bamboo; acrylic on canvas, 20" x 24" (50.8 x 61 cm)

First Snow Fall, Colorado; acrylic on canvas, 24" x 32" (61 x 81.3 cm)

Laynee's Painting; acrylic on canvas, 48" x 52" (122 x 132 cm)

Spring Birth; acrylic on canvas, 24" x 32" (61 x 81.3 cm)

Annie's First Spring; acrylic on canvas, 48" x 48" (122 x 122 cm)

Annie's Bathtub; acrylic on canvas, 24" x 48" (61 x 122 cm)

STUDENT WORKS

First Paintings by Dan's Students
All paintings are acrylic on canvas, 24" x 32" (61 x 81.3 cm).

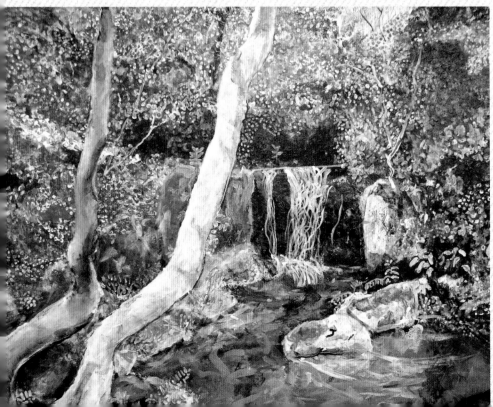

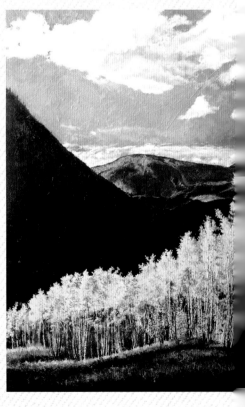

↻ (clockwise from top left)

Jake's *Sunrise*
Caroline's *Waterfall*
Shawn's *Tree*
David's *Mountain Stream*
Ann's *Aspens*
Donna's *Waterfall*

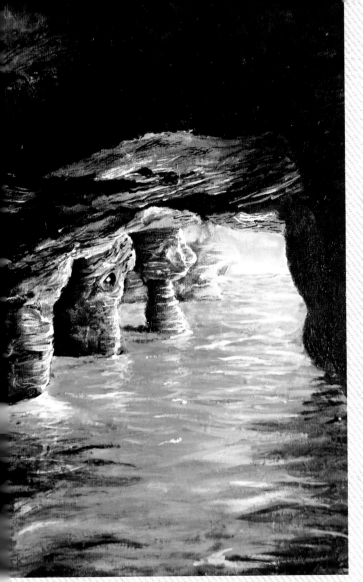

Student Works, *continued*

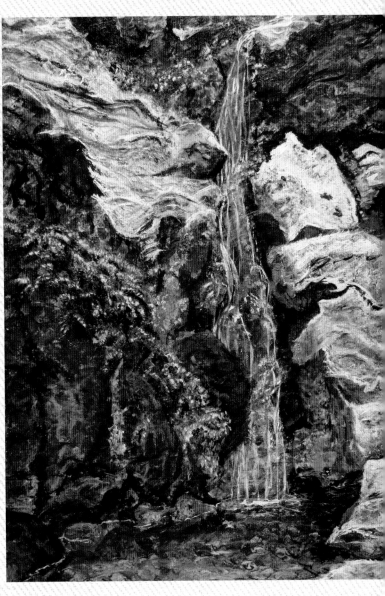

 (clockwise from top left)
Ocaddos's *Spring*
Mike's *Oregon Stream*
Katrina's *Cave Canoe Ride*
Jane's *Waterfall*
John's *Tropical Fish*
Mary Mel's *Oregon Stream*
Chad's *Waterfall*

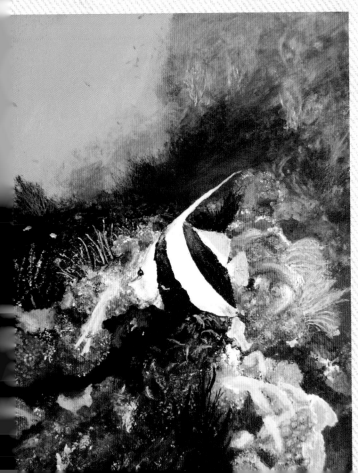

↥ Patricia's *Seacoast*

↥ Jim's *Backyard Creek*

↧ TeamMates painting class (left to right): Kendra Fry, Mariah Young, Kollena Mather, Kyle Kenney, Nickie Threet, Joy Sonderup, Dan Carrel (the author), and Christian Bansen

I Can See My Waterfall by Ann Hackerott

"Not me, I wouldn't be any good at it." In our small town of Blair, Nebraska, in the TeamMates mentoring chapter, which I coordinate in our schools, I hear those words a lot. Our mentors love to encourage student potential. Truth is, potential is a hard sell for anyone, not just for kids. We all fight against it, against a current that wants to carry us away from our dreams, our best selves. Dan Carrel convinced me that our kids could learn to step out into the deeper water with art. I have known Dan for many years and have seen the amazing paintings his students have created in his classrooms and seminars in twelve hours, without having ever touched a

⬆ "I am an artist."

brush before. Would he be interested in teaching some of our mentees how to paint a landscape? Dan said he would be happy to donate his time to our nonprofit program. I was thrilled, but when Dan told me he would enjoy working with about ten students at a time, I worried. I had hoped to give high school kids the chance, because in my experience they are least likely to come out of their comfort zone to take on new challenges that raise their confidence. I knew Dan's seminar would inspire them; but ten? I wasn't sure I could convince one of them to give up a holiday weekend for two six-hour sessions of something they had never tried before. I sent out fliers. Our mentors encouraged their kids. I worried that no one would come. Sure enough, I did not get ten kids to give up their holiday weekend. But I did get seven—seven high school kids who had never created a painting before. The evening before the workshop, I called all seven to remind them of the time. I was so nervous I called some of them twice. The next morning when we arrived an hour early to set up, put up our easels, and drape tarps across the tables and floors, the kids were waiting. Dan gathered them in a circle and said, "Raise your right hand" and, "Repeat after me: I am an artist!" They giggled quietly, "I am an artist."

Then he brought out the big voice and smile. "Louder. I am an artist!" This time they shouted it. Okay, this was already fun. Once the students had chosen a model landscape photo that inspired and challenged them, Dan brought out a bag full of peanuts in shells. He held one up and said, "This is the size of the part of your brain that tells you you aren't good enough. You have to silence that voice over and over to create this painting." Dan silenced it by crushing it under his heel. At six foot eight, this guy can crush a peanut. They all crushed their peanuts on the floor, some of them with bare feet. Dan stood the kids in a circle and asked them to raise their hands and shout, "I am a human being!" And another shout, "I am a painter!" This was even harder to say out loud without laughing. Kendra said, "Maybe I'm not human, because I'm sure no painter!" They all laughed. She crushed a peanut. Then Dan took several colors of paint and rapidly made little dots all over an art board. He raised his hand, "Repeat after me!" Of course, they shouted, "Repeat after me!" with their hands raised. He laughed and said, "I am four years old!" They loved shouting that one. He explained that when they were four, they loved color and weren't afraid to paint. He told them they were creating the chaos that would give depth to their painting. "Repeat after me, I will not cover up all the chaos!"

⬆ Mariah Young painting the chaos

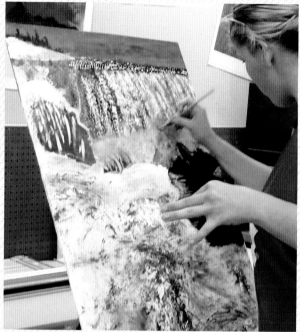

⬆ Kendra Fry in the "painting zone"

Dan taught them to stand at a distance and view their paintings with squinted eyes to discover the painting's most basic shapes. They started by painting those basic shapes. He explained light patterns, fractals, and how to turn chaos of light and dark into a clear vision with depth. So went the first day. When Gail Conyers, our assistant coordinator, thought they should be hungry, she fed them. They loved the food and talked excitely during the breaks, but none of them asked for a break; instead, they hurried back to paint, and to ask one another some of the five critical questions Dan had taught them:

"Kyle, what am I doing too much?" "I don't know but it seems like you are painting blue sky over and over." "Kendra, look at my painting and tell me what you see." Mariah and Kendra stood squinting at a painting. "I wish I had your painting, Kollena," Joy said. "I think yours is better, and so I guess we both need to crush a peanut!" They both laughed and carefully crushed their peanuts so they could also eat them. Gail and I looked around the floor covered with broken peanut shells. We looked at the

painting blobs, streaks, and triangles. Looking at the chaos of their work, I felt like crushing a pile of peanuts of my own. Dan asked, "When you bake a cake, do the ingredients in the bowl look like a cake?" "No!" came the answer from the kids. "What are all those messy ingredients in that bowl?" "Chaos?" somebody answered. "Tomorrow, by the time you leave, you will have baked a birthday cake. And in the last few minutes, you will have a powerful painting that lights the candles." The next day, the class was to start at nine o'clock. Most of the kids were waiting outside the school before it opened at eight. They went straight to their paintings and began to paint. Dan stopped by each one to offer a comment or question or to sit down and show a brush technique. But they didn't ask for much help. Something amazing was happening. Kendra was on her knees on the tarp, applying a clear coating with bare hands, sure strokes, and intensity in her face. The hair was in her eyes and she didn't care, she just swept it back and kept moving. "Kendra," I said, "look at your painting." She looked at me seriously. "I know."

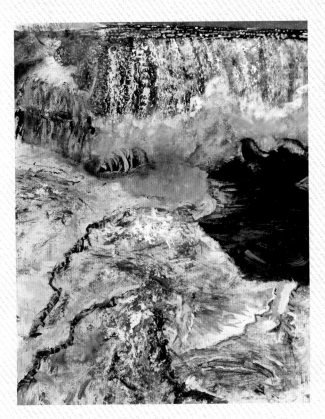

↑ **Kendra Fry's finished Niagara Falls painting**

↑ **Joy Sonderup can see her waterfall!**

Joy, who had only three more hours to paint, waited for Dan to tell her what to do next. Dan stood across the room and said, "Joy, I have told you everything you need to do to paint your landscape." Sighing, she said to herself, "I think I need more peanuts." She crushed a few, and then settled down at her easel and began painting trees. Dan had shown her a technique for painting trees and she liked it. Trees and more trees grew above a long blue blob. She looked peaceful. I felt less than peaceful. What if they all didn't finish? What if some were disappointed? I felt a tug at my elbow; it was Joy's hand. She wanted more instruction and there was no more to give her, so I did the best I could for her by looking at her with sympathy. "Ann," she said with wide eyes and a smile, "come see!" She pulled me over to her painting. "See what?" I looked at her painting. "What is it?" Quietly she said, "I see my waterfall." I looked at her. She was squinting and then her eyes were gleaming, "I see my waterfall!"

She smiled and went to work. A long, graceful waterfall, gently flowing over the rocks, began to appear. She was in that current, she knew where it was headed, and by the look on her face it was someplace gentle.

Kendra had also chosen a waterfall but hers was different, powerful; you could almost hear it thunder. And she too, was not afraid. As the last hours rolled on, each student painted with his or her own grace. I had known these kids for years but felt like I was seeing them for the first time. Kyle stood looking at his painting, cocking back one broad shoulder at a time. The painting was his. No one could convince him his cavern was upside down compared to the model photo he had selected. He liked it better that way. He chose the most challenging of the hundred or so photos Dan had provided. He was his own man. Mariah stroked her trees with a plastic pot scraper that was turning her trunks into real bark. The chaos that she had carefully laid on in layers had become a distance of intrigue and depth. Christian was painstakingly painting trees up the side of the mountain. I looked around the room and I saw landscapes. "Christian, it's happening!" I said.

↑ Christian Bansen's mountain

↑ Nickie Threet about to light the candles

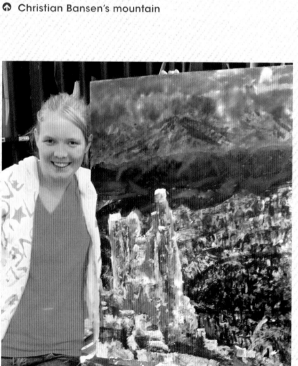

↑ Kollena Mather's canyon painting

Christian never took his eyes off the mountain. "No, Ann, it's happenin'! Say it right!" Kollena looked deep into her canyon with a smile. She said, "I know I'm not done, but I don't care. I'll quit. I never expected to do anything this good in my life." Nickie meticulously worked on her mountain, sitting still and focused for an hour at a time in a lotus position.

"Dan, have I lit the candles?" she asked. Dan sat down at her painting. "Yes!" And without any prompting, we all began to sing "Happy Birthday."

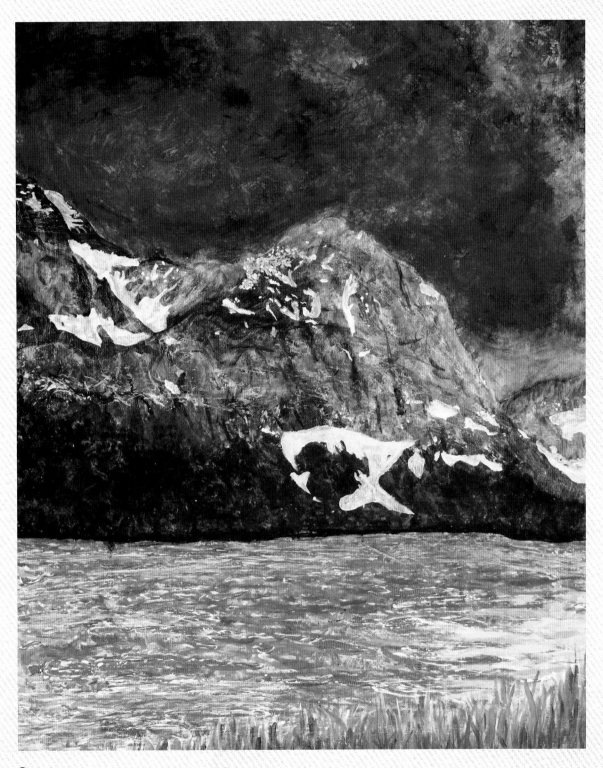

⬆ Nickie Threet's finished mountain painting

ACKNOWLEDGMENTS

To my beautiful, loving, and amazing artist bride, Annie, who always believed in me even when I did not. Bless my seven children and six grandchildren, who have given me invaluable insight about what's most important in life. They gave me a world and life worth living.

I would like to thank Mary Ann Hall, my editor, for believing in this book giving me a wonderful chance of a lifetime. Thank you, Pat Price, technical editor; without your amazing patience and writing skill I could not have brought this story into the light. And many thanks to Betsy Gammons, my tireless project manager, and the dedicated design staff.

Thank you Glenny Densem Moir with Art & Soul Retreats (www.artandsoulretreat.com) for the opportunity to teach these painting techniques in your workshops.

To my sister, Ann, who is an inspiration to us all. She is a powerful author, a poet of life, and mother with a deep love and commitment for children that have been marginalized by our institutions. I would also like to thank the TeamMates programs that mentor our most important resources in the world: children!

My complete heartfelt gratitude goes to the countless number of students, so many that I will never be able to name; people who chose the courage to go beyond fear and let that wise "Child's" voice back into their lives. Thank you for the honor and life-transforming opportunity in helping to midwife your wise Child's birth. To all the countless, powerful photographers whose images have inspired my student's journeys; because of your genius you gave my students the necessary inspirational keys to open the door to their personnel artistic birthright. As you know, that has always been the highest honor for the artist in community. Your work accomplished the true function of art: to help transport all of us to a higher understanding of this beautiful natural world.

To all the educators who teach to learn, who are brave enough to go outside of their own thinking and learning styles, inspiring students instead of cloning them—your tireless efforts give children and society a chance for harmony and self-worth instead of polarized conflict. Thank you to all the parents who tirelessly fight for their children's intellectual birthright to be whole and validated in monointellect public school systems. Art's function is to provide society a way to transcend to a balanced, symbiotic, loving community. If you are human, you are an Artist! Thank you all for supporting art education.

ABOUT THE AUTHOR

Dan Carrel is a masterful artist who has been teaching art for more than thirty-four years. Although he has taught at five universities and colleges, much of his experience and passion focuses on helping nontraditional students learn or relearn to access the mental functions associated with art. What motivates him is a deeply held conviction that artistic expression is the birthright of every living soul, and it is his mission to help you access that divine right. Dan shows his students how to create the underlying painting structure of color chaos, which allows the student to see and discover the basic visual patterns that are needed to complete a realistic painting. Even if you have never picked up a paintbrush, you'll find yourself painting beyond your wildest expectations.